D1035341

The Artful Table

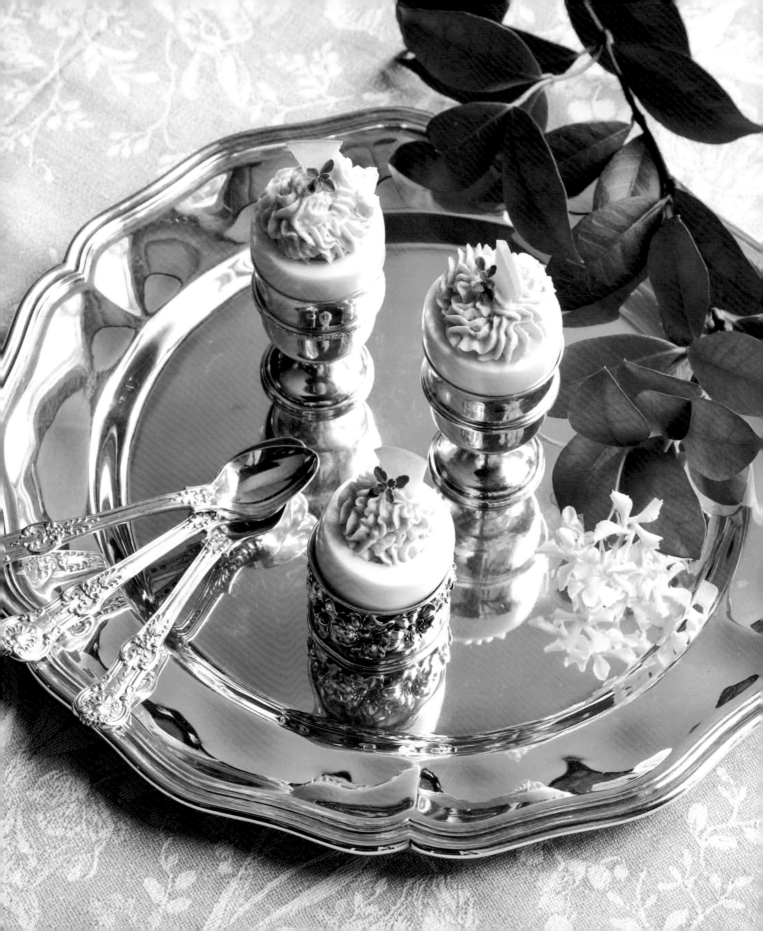

The Artful Table

MENUS & MASTERPIECES FROM THE TELFAIR MUSEUMS

TELFAIR ACADEMY GUILD

TELFAIR BOOKS

SAVANNAH, GEORGIA

© 2011 Telfair Books, an imprint of Telfair Museums

All rights reserved. No part of this publication may be reproduced
without prior written permission of the publisher.

Library of Congress Control Number: 2011935464
ISBN-978-0-933075-16-0
EAN9780933075160

Published by Telfair Books
Distributed by the University of Georgia Press
www.ugapress.uga.edu

Produced by Pinafore Press / Janice Shay and Sarah Jones
Editor: Linda McWhorter

Food photography by Deborah Whitlaw Llewellyn

Additional photography by:
Wayne C. Moore, pp. 9, 21, 53, 111, 118
Peter Harholdt, pp. 10-11, 12, 30, 46-47, 58, 84-85, 116, 124-125, 126, 134, 142, 150
Nurnberg Photography, pp. 22, 38, 66, 76, 86
Danile L. Grantham, Jr., pp. 48, 121
David J. Kaminsky, p. 96
Erwin Gaspin, p. 106

Cover image:
Alfred Smith (French, 1854 – 1936)
Le dejeuner sous les bois (Luncheon under the Trees), 1903
Oil on canvas, 47 1/2 x 59 1/2 in. (120.7 x 151.1 cm)
Gift of George J. Baldwin, Alexander R. Lawton, Willie W. Mackall
and J. Florence Minis. 1907.3

Printed in Canada

TELFAIR
MUSEUMS

Savannah, GA
www.telfair.org

Contents

Glass, c.1857
Engraved red glass
Bequeathed by Margaret
Gray Thomas, 1951

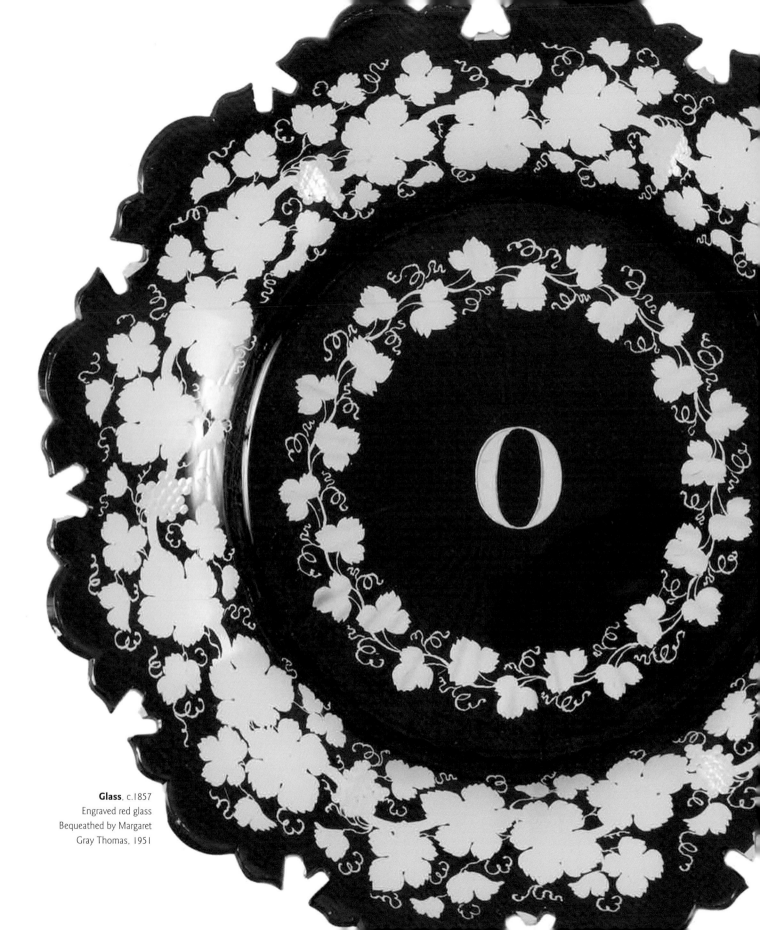

Glass, c.1857
Engraved red glass
Bequeathed by Margaret
Gray Thomas, 1951

Introduction

Art inspires and the art of the Telfair Museums has been inspiring visitors for 125 years by presenting, preserving and collecting works of art. The tradition continues, from founder Mary Telfair's collection and the early acquisitions of Carl Brandt to the most recent purchase by the Gari Melchers Collectors' Society, *Vespers* (fig. 1), and the reframing of *La Parabola* (fig. 2). To celebrate those twelve decades, Telfair Academy Guild, the museums' largest member group, launched a culinary project—a book of menus inspired by the Telfair's masterpieces. The result is this beautiful book, *The Artful Table: Menus and Masterpieces from the Telfair Museums.*

Telfair Academy Guild was formed thirty-five years ago and has grown exponentially since that

fig. 1
Julius Gari Melchers
(American, 1860-1932)
Vespers, c. 1892
Oil on canvas
47 1/2 x 38 1/4 inches
Museum purchase in honor of
Holly Koons McCullough with
funds provided by the Gari
Melchers Collectors' Society and
Dale and Lila Critz 2011.9

fig. 2

Cesare Laurenti
(Italian, 1854-1936)
La Parabola (A Parable), c. 1895
Oil on canvas
Diptych: 87 x 113 in. each
Museum purchase 1900.6.a-b

fig. 3

Dining Table, 1836
Mahogany, oak, pine, h.28 1/2 in. (72.4 cm)
Diam. without leaves, 52 ½ in. (133.3 cm)
Diam. with large leaves, 85 ½ in. (216.2 cm)
Bequest of Mary Telfair 1875.57

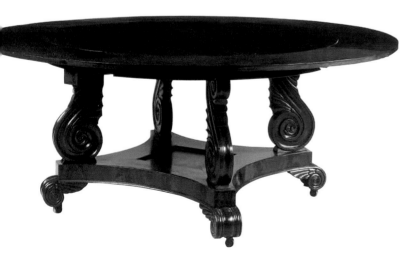

year, raising funds for the Catalogue of the Permanent Collection, the Dutch Utopia exhibition, preservation of the family dining room and the façade at the Owens-Thomas House, as well as purchasing art such as *Savannah City Market* that inspired the Fall menu Celebrate the Harvest. Through the dedication of its nearly 400 members over the years, funds were provided for reframing George Bellows' *Snow-Capped River*, the Technology and Art Gallery at the Jepson Center and the ever popular Lecture Series with its incredible Opening Receptions to name a few. Their talented members embraced the project to honor the 125th anniversary and began formulating a plan of action.

The collection was surveyed for works that contained food or dining but though diverse in many ways, the collection contained no such art. What it did contain, however, were various elements that comprise the dining experience. A dining table by Thomas Cook of Philadelphia, purchased by Mary and Margaret Telfair for the mansion in 1836, for which they paid $100, continues to be on view today (fig.3). Mary Telfair's silver tea service and also that of Margaret Thomas (fig. 4) are in the museum's possession, suggesting the importance of taking tea, celebrated in the menu *Under the Garden Umbrella* on

fig. 5

Samuel Child Kirk
(American, Baltimore, Maryland,
1792–1872, active 1815–72)
Vegetable dish, covered (one of a pair)
7 x 10 7/8 x 7 7/8 inches
OT1951.196.2.a-b

fig. 4 (below)

Samuel Kirk & Son
(American, Baltimore, Maryland,
1846–1861, 1868–1896)
Teapot, 6 1/4 x 10 9/16 inches
OT1951.163

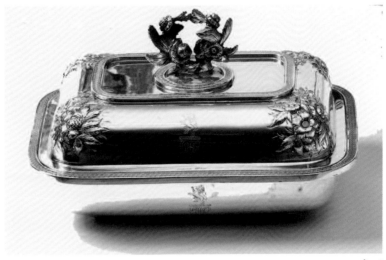

fig. 5

page 13. A covered vegetable dish by Samuel Kirk (fig. 5) and an engraved red glass from the Owens family (see pages 5 and 6) document dining traditions from the late nineteenth century. The kitchen is an essential element in the art of dining and there are two period kitchens to be visited, one at the Academy and one at the Owens-Thomas House. A piece by Francois Bonvin, *La Cuisine*, alludes to the act of cooking and the realization that all these elements were part of the museum gave birth to TAG's anniversary project.

Many of the chefs involved with catering at Telfair Museums were inspired to create menus from works in the collection and took up the challenge with gusto. Organized by seasons, the menus and masterpieces were brought together with the recipes and the result is a glorious celebration of art and dining, enticing the reader with a variety of flavors, from Nick Mueller's Oysters with Carmelized Onions, Bacon, and Asiago Cheese to Cynthia Creighton-Jones' Cardamon and Anise Marinated Oranges. The process so excited the TAG Committee, charged with the awesome task of tasting the recipes, that they became inspired as well and contributed entries of their own. ***The Artul Table: Menus and Masterpieces from the Telfair Museums*** is a tribute to the energy and dedication of the Guild's many members and to the strength of the institution they so generously serve. Be inspired!

Linda McWhorter, Chairman
Elisabeth Biggerstaff
Sharon Singstock Bury
Jettie Hearne
Beth Logan
Carolyn Neely
Kelly Newberry
Sylvia Severance

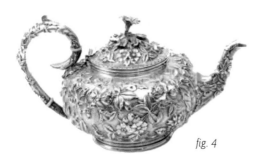

fig. 4

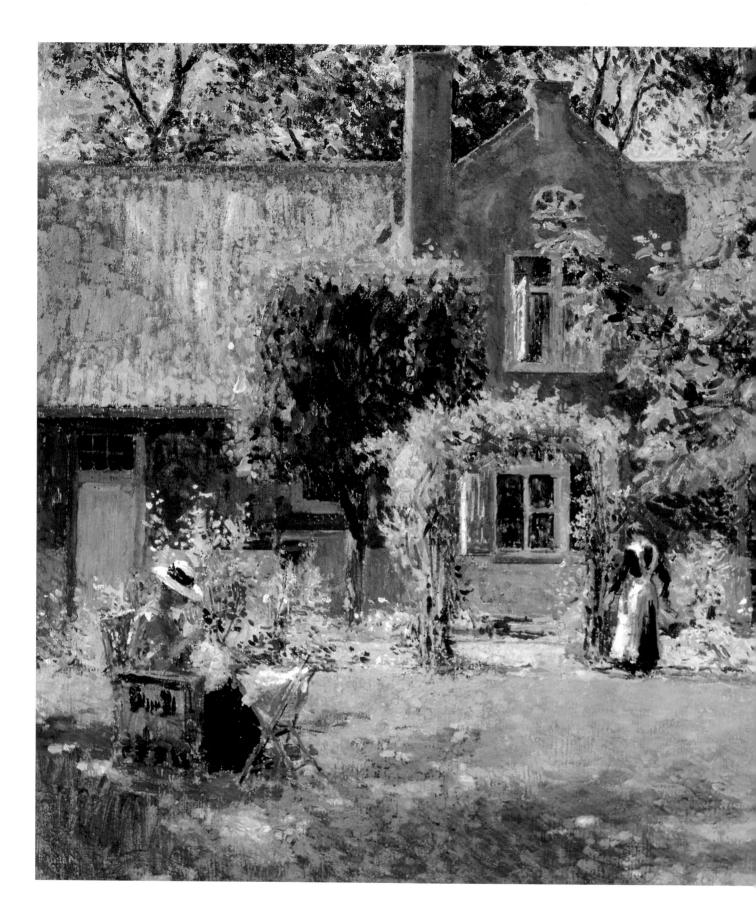

G. Melchers.

Spring

Under the Garden Umbrella
Menu by the Committee

Fêtes Accomplies
Menu by Susan Mason

Springtime Sonata
Menu by John Nichols

Crustaceans and Castanets
Menu by the Committee

Gari Melchers (American, 1860–1932)
The Unpretentious Garden, c. 1903–9
Oil on canvas, 33 5/8 x 40 in. (85.4 x 102.9 cm)
Signed lower right, *G. Melchers*
Museum purchase, Button Gwinnett Autograph Fund 1916.5

On a ship to Europe in 1902, Gari Melchers met Corinne Mackall, a Savannah-born art student on her way to Paris. Despite an age difference of twenty years, they began a courtship culminating in a loving relationship that lasted until Melchers' death in 1932. By virtue of Corinne's family connections, their marriage would also lead to a happy union between them and the Telfair Academy of Arts and Sciences. Melchers served as the museum's fine arts advisor from 1906 to 1916, while residing primarily in the small Dutch village of Egmond aan den Hoef in northern Holland.

Until his marriage in 1903, Melchers was primarily known for naturalistic portrayals of Dutch village life, rendered in a bright palette. *The Unpretentious Garden*, a celebration of domestic tranquility, may be among the first examples of Melchers' new focus on middle-class women painted in an impressionistic mode. While genre painting would continue to be important to him, Melchers' own peaceful domestic life, anchored by Corinne, became his primary subject matter. In keeping with his new theme, *The Unpretentious Garden* depicts the backyard of the Melchers' home on School Street in Egmond aan den Hoef. Corinne, seated on a bench at the left, placidly works at her needlework, her face protected from the sun by a wide-brimmed hat. Some distance behind her, a maid waters flowers near the house. In this tranquil sunlit scene, large trees cast shadows across the lawn, flowers bloom, and the pale green of new growth evokes springtime with thoughts of gardens, fêtes, music and dance.

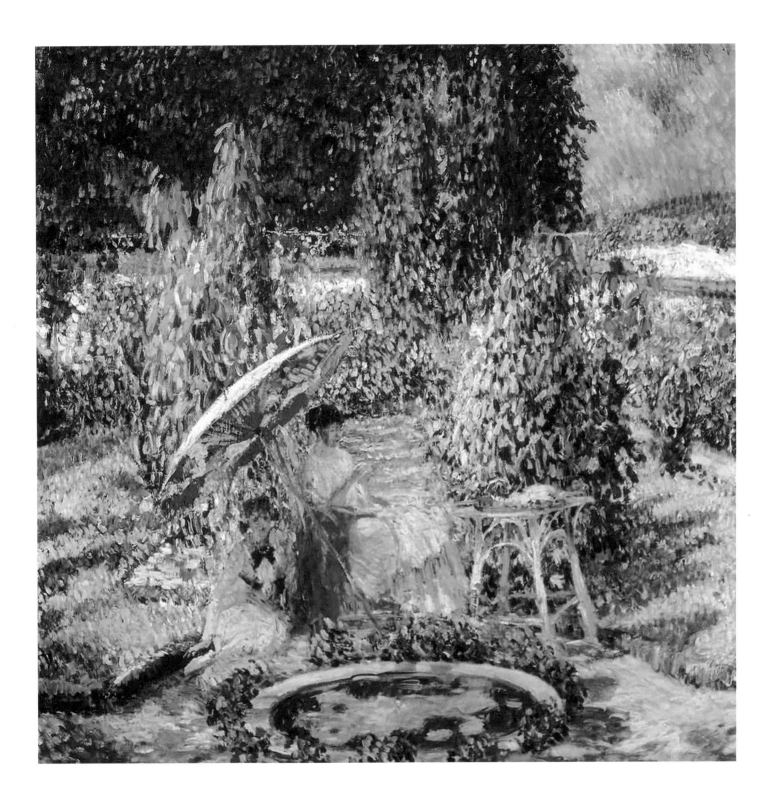

Under the Garden Umbrella

MENU BY
The Committee

Chilled Sweet Pea Shooters

Scones with Georgia Peach or Fig Preserves
and Devonshire Creme

Curry Devilled Eggs with Green Apple

Tea Sandwiches:
Radish, Cucumber, and Watercress
with Lemon Mayonnaise
Pimento Cheese

Tomato Basil Tart

Smoked Salmon Pinwheels

Angel Cakes with Lemon Sauce and Berries

Frederick Carl Frieseke
(American, 1874-1939)
The Garden Umbrella, c. 1910
Oil on canvas, 325/16 x 325/16 in.
(82.1 x 82.1 cm)
Signed lower right, F. C. Frieseke
Bequest of Elizabeth Millar Bullard 1942.7

The Garden Umbrella portrays elegant women taking tea in a sun-filled garden. The varied and transformative effects of light were the subject frequently chosen by the artist Frederick Carl Frieseke in his years in Giverny, a colony of American Impressionists drawn there by the presence of Claude Monet. Executed with short, choppy brushstrokes, the work displays Frieseke's emphasis on the decorative patterns of flowers, the dazzling sunlight and patches of shadow, and the flat surface of the picture plane. The garden umbrella provides additional patterning and color for the artist's brush. Elizabeth Millar Bullard, a museum trustee during Gari Melchers' directorship who followed his lead in building her art collection as he built the Telfair's, purchased the work and later bequeathed it to the museum. The sitters' relaxed poses suggest a leisurely spring afternoon perfect for a tea in the garden.

Chilled Sweet Pea Shooters

serves 10

1-pound bag frozen green peas, thawed
1 cup chicken broth
2 scallions, cut into 1-inch pieces
1/4 cup packed fresh mint leaves
1/3 cup sour cream
1/2 teaspoon kosher salt
1/4 teaspoon fresh ground black pepper
Additional sour cream, thinned with milk

In a blender, puree the peas, broth, scallions, and mint until the mixture is very smooth. Scrape the mixture with a rubber spatula through a fine-mesh sieve set over a bowl. Discard the pulp in the sieve. Whisk in the sour cream, salt, and pepper until smooth. Cover and refrigerate until cold. (Soup may be made the day before and refrigerated until ready to serve.)

To serve, fill cold shot glasses with about 1/4 cup of the pea soup per glass. Garnish with a tiny dollop of thinned sour cream.

Scones with Georgia Peach or Fig Preserves and Devonshire Creme

serves 12

Scones
4 cups flour
1 teaspoon salt
4 tablespoons baking powder
8 tablespoons sugar
1 cup (2 sticks) cold butter, sliced
1 1/2 cups buttermilk

Scone Topping
2 egg yolks, beaten
1/4 cup sugar

Garnish
1 (7-ounce) jar Georgia peach, or Devonshire
 fig preserves
Devonshire creme (available in dairy
 section of grocery)
12 strawberries, cut into fan shapes

Preheat the oven to 425 degrees F.

Mix together the flour, salt, baking powder, sugar, and butter in a large bowl until the butter is the size of small peas. Beat in the buttermilk until the dry ingredients and the butter are well blended—do not over beat. Spread the mixture evenly into 2 lightly buttered 10-inch glass pie plates. Cut the dough to form 6 wedge-shaped scones. Glaze the top of the scones with the egg yolk and sprinkle the top with sugar. Bake for 20 to 25 minutes, or until the tops of the scones are golden.

Serve the scone wedges on a plate with the fruit preserves and Devonshire creme. Garnish with strawberries cut into a fan shape.

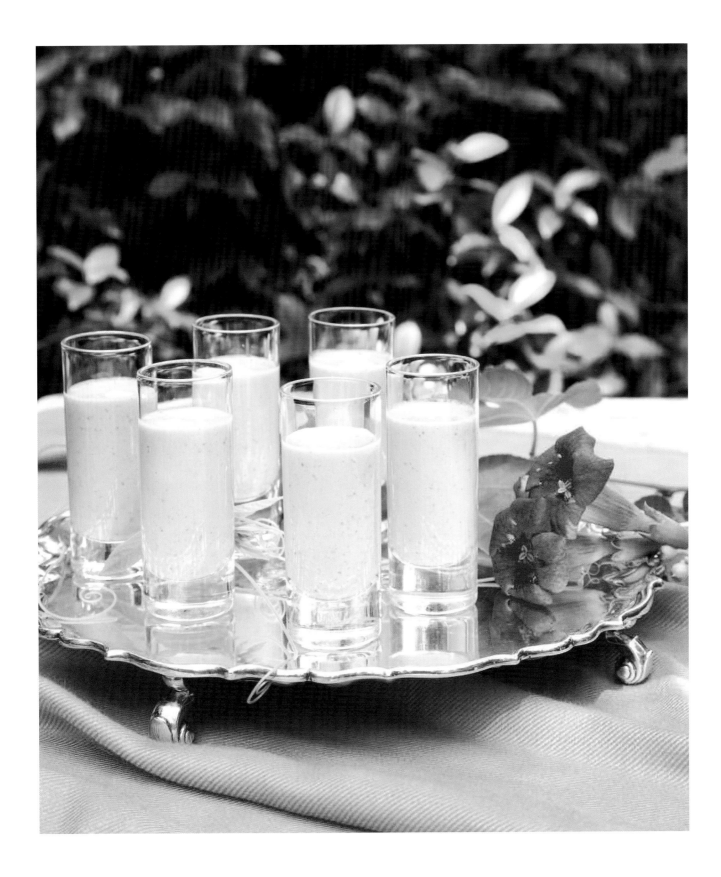

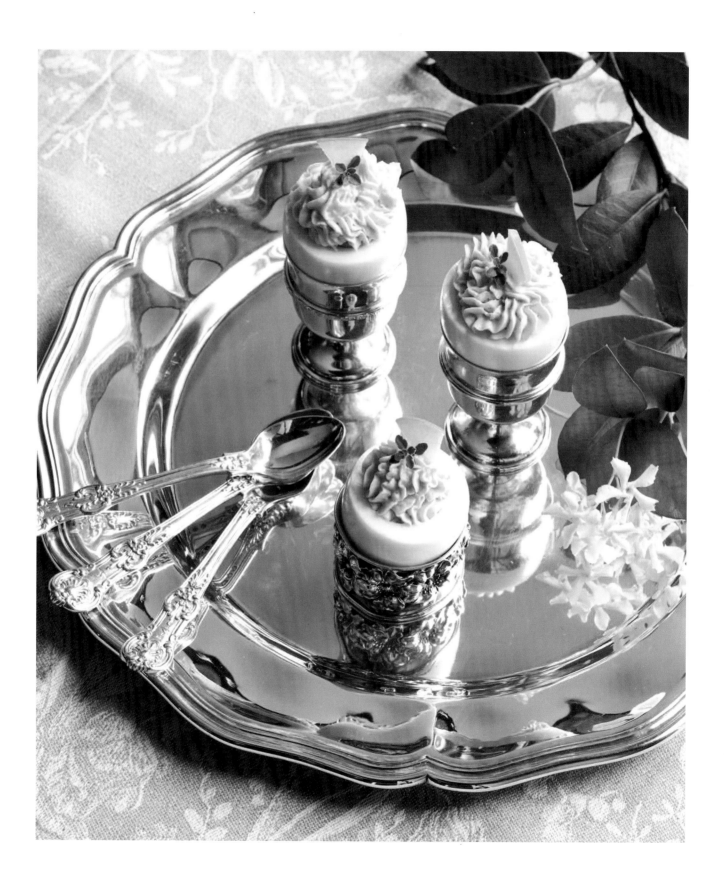

Curry Devilled Eggs with Green Apple

yields 2 dozen

12 large hard cooked eggs peeled
2/3 cup mayonnaise
1 tablespoon Dijon mustard
1 teaspoon curry powder
1/4 teaspoon black pepper
1/4 teaspoon salt
1/2 Granny Smith green apple, finely chopped,
 with 2 tablespoons set aside for topping
Thyme, for garnish

To hard boil eggs, gently place them in a single layer in a medium saucepan, add enough cold water to cover, and bring to a boil over medium heat. Remove the pan from the heat, cover, and allow the eggs to sit for 15 minutes. Drain, add ice water, and allow the eggs to cool completely. Peel and slice the eggs in half, remove the yolks, and place them in a medium bowl. Mash the yolks with a fork, and stir in the mayonnaise, Dijon mustard, curry powder, pepper, and salt until the eggs are smooth and creamy. Add the finely chopped apple. Spoon or pipe the filling into the egg white halves and refrigerate for 1 hour, or until you are ready to serve. Top each devilled egg with a small sliver of the green apple, or garnish with the reserved chopped apple and thyme.

The Garden at the Owens-Thomas House

Located between the main house and the slave quarters and carriage house, the space known today as the garden was originally a service area, possibly containing a kitchen garden and place to hang laundry. A well at the rear, near the slave quarters, provided drinking water for all the inhabitants. In 1956 Clermont H. Lee, Savannah's famous landscape designer, created the formal garden much like the one painted by Frieseke in *The Garden Umbrella*.

Radish, Cucumber, and Watercress Tea Sandwiches with Lemon Mayonnaise

 serves 16

Lemon Mayonnaise
1 cup mayonnaise
2 tablespoons grated lemon zest
2 teaspoons coarse grain mustard
2 teaspoons lemon juice
Salt
Pepper

Sandwiches
16 slices white bread, very thin
16 slices wheat bread, very thin
1 cup watercress leaves
1 English seedless cucumber, thinly sliced
16 radishes, trimmed and thinly sliced
1 tablespoon mint leaves, finely chopped
1/2 teaspoon sea salt

To make the lemon mayonnaise, combine the mayonnaise, lemon zest, mustard, lemon juice, and salt and pepper to taste in a small bowl and blend well.

Spread the slices of white and wheat bread generously with the lemon mayonnaise and assemble as follows, beginning with the bottom layer:

1. White bread with cucumber
2. Whole wheat bread with watercress
3. White bread with radishes, sprinkled with a pinch of salt and mint leaves (sandwich may be served open-faced at this point)
4. Top with a slice of whole wheat bread and press gently together

Carefully trim the crusts and cut sandwiches in half diagonally. The sandwiches can be made two hours ahead and refrigerated, covered, until ready to serve.

Pimento Cheese Tea Sandwiches

serves 12

8 ounces extra sharp cheddar cheese, finely grated
2 ounces cream cheese, softened
1 (7-ounce) jar pimentos, drained
3 tablespoons mayonnaise
1 teaspoon salt
1 teaspoon pepper
1 teaspoon cayenne (optional)
12 slices thin sandwich bread of your choice

Mix the grated cheese, cream cheese, and the pimentos together in a medium bowl until well blended. Add the mayonnaise, salt, pepper, and cayenne and mix well.

Spread a thin coating of the pimento mixture on top of each slice of bread. Make the sandwich by placing the spread sides together. Trim the crust from the bread, cut each sandwich into quarters, and serve.

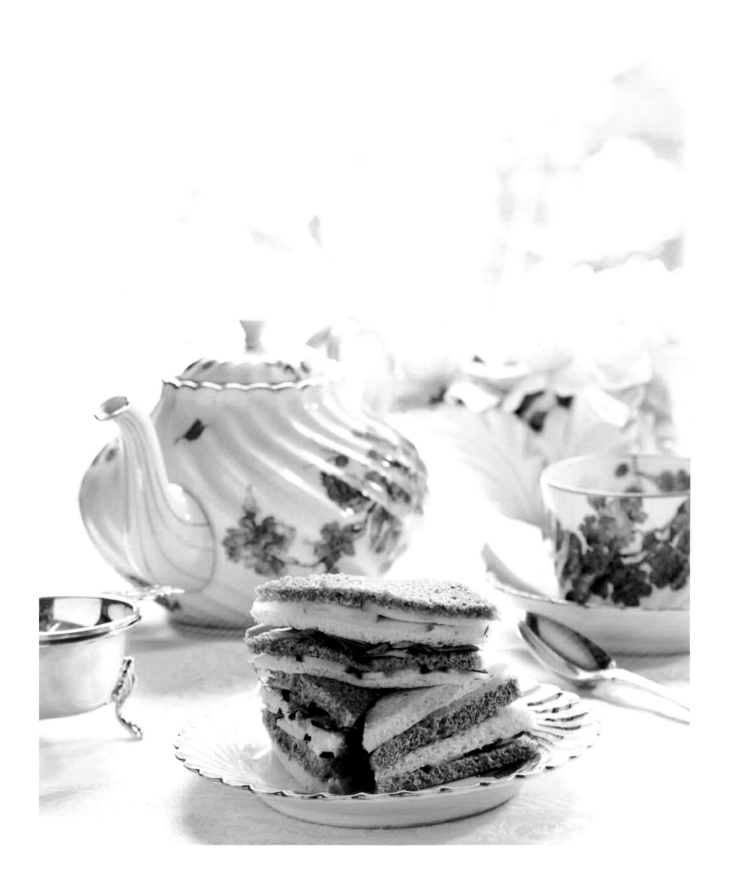

Tomato Basil Tart

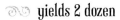 yields 1 (9-inch) tart

3 large tomatoes, cut in 1/2-inch slices
Pinch salt
1 single crust pie pastry shell
2 tablespoons prepared pesto (available
 in jars in your grocery)
6 ounces shredded mozzarella
2 eggs
1 cup heavy cream
1 teaspoon salt
1/2 teaspoon pepper
2 tablespoons fresh basil, chiffonade

Sprinkle the tomato slices with salt and place them in a colander to drain for 30 minutes. Remove the tomatoes from the colander and pat dry.

Preheat the oven to 350 degrees F.

Place the pie crust in a 9-inch tart pan. Press the crust against the sides and bottom of the pan, crimp or flute the edges, and trim off any excess pastry dough.

With a spatula, spread the pesto on top of the tart crust until well coated. Top the pastry crust with the mozzarella and tomato slices.

In a small bowl, beat together the eggs and cream. Season with salt and pepper and pour the mixture over the tomatoes. Bake the tart for 30 minutes, or until the pastry is a pale gold color and the tart filling has set. Sprinkle the top of the tart with the fresh basil. Cut into 12 small slices and serve.

Smoked Salmon Pinwheels

yields 2 dozen

8 ounces Boursin cheese or garlic herb
 cheese spread
6 medium flour tortillas
8 ounces smoked salmon, thinly sliced
4 tablespoons red onion, finely chopped
2 tablespoons capers (optional)
Fresh dill, red onion slices, or capers,
 for garnish

Spread a thin layer of the cheese spread on top of each tortilla. Place the thin slices of salmon in the middle of the tortilla. Top with the red onion and capers, if desired. Roll the tortillas and wrap them in plastic wrap. Place the wraps in the refrigerator for at least 1 hour, or for up to 24 hours.

Remove the wraps from the refrigerator and unwrap the tortillas from the plastic. Cut the rolls into 1-inch slices. Place the slices on a tray and garnish with the fresh dill, red onion rings, or capers to serve.

Angel Cakes with Lemon Sauce and Berries

yields 2 dozen

Cakes

1/2 cup cake flour, sifted before measuring
2/3 cup sugar, divided
6 large egg whites, room temperature
3/4 teaspoon cream of tartar
1/8 teaspoon salt
1/2 teaspoon lemon extract

Lemon Sauce

2 egg yolks
1/3 cup granulated sugar
1/3 cup butter, melted
1 tablespoon grated lemon rind
2 tablespoons lemon juice
1/3 cup heavy cream, whipped
Raspberries, for garnish
Blueberries, for garnish

Samuel Kirk & Son (American, Baltimore, Maryland, 1846–1861, 1868–1896)
Mary Telfair Tea Service 1959.9.6.

Preheat the oven to 325 degrees F. Set out 24 regular muffin cups, bottoms lined with rounds of parchment or wax paper. Do not grease the cups.

In a small bowl, combine the flour and 1/3 cup sugar. In a separate large bowl, stir together the egg whites, cream of tartar, salt, and lemon extract. Beat the egg whites until frothy. Slowly add the remaining 1/3 cup sugar and continue beating at high speed until the whites are stiff. Using a rubber spatula, fold the flour mixture into the egg whites. Divide the batter evenly among the muffin cups.

Bake for 10 to 12 minutes, or until the cakes feel dry when touched in the center. Be careful not to overcook. Remove the cakes from the oven and allow them to cool on a rack until ready to serve. (The cakes can be made ahead of time and frozen.)

While the cakes are baking, make the lemon sauce. Beat the egg yolks until they become thick and lemon colored. Gradually add the sugar, continuing to beat. Add the butter, lemon rind, and juice and mix to blend. Fold in the cream and chill in the refrigerator until ready to serve.

To serve, loosen the edges of the cakes with the tip of a thin knife and lift the cakes out of the pans. Arrange them on a dessert plate and spoon the lemon sauce over each cake. Garnish with raspberries and blueberries and serve.

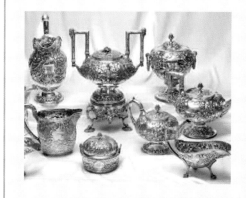

The Ritual of Tea

Early Georgia colonists embraced the British ritual of tea as a mark of civility and welcome. It was served in the drawing rooms of upper class homes in the afternoon, and was a considerably less expensive way to entertain and socialize than a formal dinner. The servants were taught exactly how to prepare the tea, but it was the lady of the house who poured it for her guests. Today, a tea is an afternoon gathering, often a celebration of a happy event, which calls for a selection of teas, as well as sweet and savory morsels such as scones, cake, and sandwiches.

Fêtes Accomplies

MENU BY
Susan Mason

Yellow Tomato Gazpacho

Watermelon, Arugula, and Pine Nut Salad

Ham and Sweet Potato Biscuits

Crab Mousse

Asparagus Quiche

Rosemary Salmon

Coconut Pound Cake

Jean-François Raffaëlli
(French, 1850–1924)
La demoiselle d'honneur
(The Maid of Honor), c. 1901
Oil on canvas, 99 x 45 3/8 in.
(251.5 x 115.3 cm)
Museum purchase 1910.2

Jean-François Raffaëlli's elegant *La demoiselle d'honneur* was purchased for the Telfair by artist Gari Melchers, who considered Raffaëlli to be "one of the biggest men in France" during the early decades of the twentieth century. The lush impressionistic brushwork and striking vertical orientation of the composition, combined with the glamorous attire of the Parisian bridesmaid, have made this painting a perennial favorite of Telfair visitors. Raffaëlli never reveals the actual bride and groom, focusing solely on the fashionable bridesmaid, absorbed with the proceedings. While there is certainly no clear narrative, the viewer nonetheless ponders the mysteries of the bridesmaid's expression. Is it one of respectful attention and tacit approval—or is it marked by wistful regret? The infinite variety of whites that dominate the palette, the frothy textures of dress and hat, and the profusion of white daisies imply the freshness and fecundity of a spring celebration.

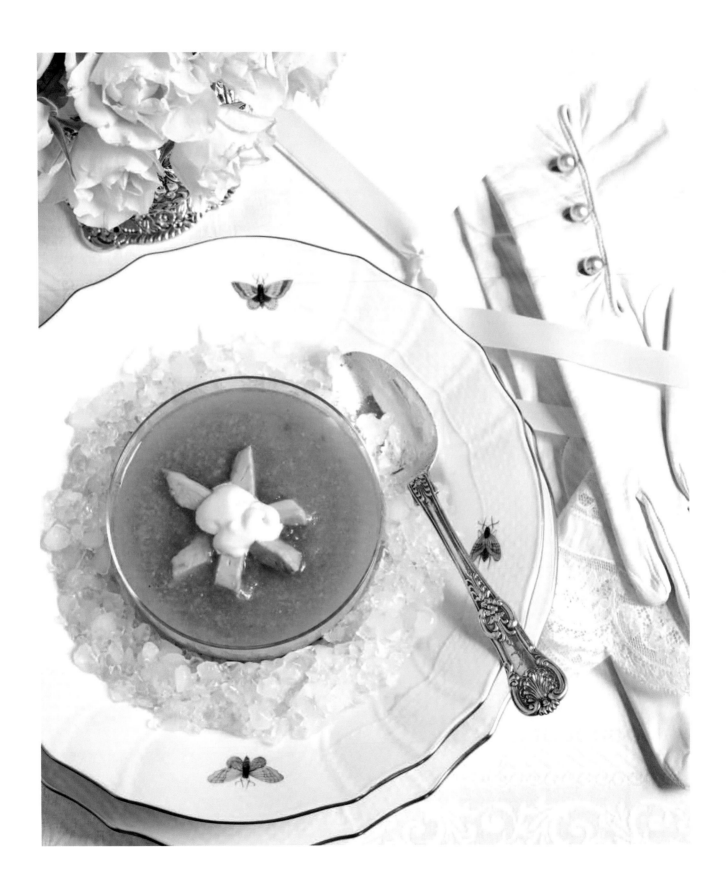

Yellow Tomato Gazpacho

❧ serves 8

5 pounds fresh yellow tomatoes, cored,
 and chopped
1/2 cucumber, peeled, seeded, and chopped
2 stalks celery, chopped
1 yellow bell pepper, seeded and chopped
1/2 jalapeño, seeded and chopped
1/2 Vidalia onion, chopped
1/2 teaspoon fresh garlic, minced
1 tablespoon fresh lemon juice
1 tablespoon Champagne vinegar, or
 white wine vinegar
1/2 teaspoon ground cumin
1/2 teaspoon celery salt
3 tablespoons extra virgin olive oil
1/2 teaspoon Louisiana hot sauce
1 1/4 teaspoons sugar
Salt
Fresh ground black pepper
8 to 10 tablespoons crème fraiche, for garnish
4 avocados, peeled, and sliced, for garnish

Combine the tomatoes, cucumber, celery, bell pepper, jalapeño, and onion in a food processor and puree. Refrigerate the mixture until chilled.

Add the garlic, lemon juice, and vinegar and mix well. Add the cumin, celery salt, oil, hot sauce, sugar, and salt and pepper to taste. Refrigerate until the mixture is cold and ready to serve.

Serve the gazpacho in demi cups set over ice. Garnish each serving with a dollop of crème fraiche and fanned-out avocado slices.

Watermelon, Arugula, and Pine Nut Salad

❧ serves †

1 tablespoon fresh lemon juice
1 tablespoon red wine vinegar
1/2 teaspoon salt
2 tablespoons extra virgin olive oil
3 cups watermelon, seeded and cut into
 1/2-inch cubes
6 cups baby arugula
1/2 cup pine nuts
1/3 cup crumbled feta or fresh goat cheese
Coarsely ground black pepper
Fleur de sel (optional)

Whisk together the lemon juice, vinegar, and salt in a large bowl. Add the oil in a slow stream, whisking until emulsified. Add the watermelon, arugula, and pine nuts and toss to coat. Sprinkle with the cheese, pepper, and fleur de sel (if desired). Divide the salad evenly among serving plates and serve immediately.

Ham and Sweet Potato Biscuits

❧ yields 3 dozen

1/4 cup cooked sweet potatoes, lightly mashed
2/3 cup milk
1/4 cup (1/2 stick) butter, melted
1 1/4 cups all-purpose flour, sifted
1 tablespoon sugar
4 teaspoons baking powder
1/2 teaspoon salt
1 pound country ham, thinly sliced

Cranberry Mayonnaise
1 cup mayonnaise
1/2 (14 1/2-ounce) can jellied cranberry sauce

Preheat the oven to 450 degrees F. Lightly grease a large baking sheet.

Combine the sweet potatoes, milk, and butter in a large mixing bowl. Sift together the flour, sugar, baking powder, and salt and mix into the potato mixture to form a soft dough. Knead the dough on a lightly floured surface until smooth and roll out to a 1/2-inch thickness. Cut the biscuits with a 2-inch biscuit cutter and transfer to the prepared baking sheet with the edges touching. Bake for 8 to 10 minutes, or until golden brown. Remove from the oven and allow to cool on the baking sheet.

To make the cranberry mayonnaise, process the mayonnaise and cranberry sauce in a food processor until smooth. Set aside.

Slice the biscuits in half, spread them with the cranberry mayonnaise, and fill with the ham. Wrap the biscuits in foil, making 2 layers of biscuits. Warm them in the oven at 350 degrees F for 15 minutes and serve. They can also be refrigerated in foil overnight and heated in a 350 degree F oven for 25 to 30 minutes.

.

Crab Mousse

❧ serves 10 to 12

1 1/2 tablespoons unflavored gelatin
1/4 cup cold water
3/4 cup mayonnaise
3 tablespoons fresh lemon juice
1/4 small onion, grated
2 pounds jumbo lump crabmeat
1/3 cup heavy cream
Salt
Fresh ground black pepper

Sprinkle the gelatin over the cold water in the top of a double boiler. Let the gelatin soften for 5 minutes. Place the top of the double boiler over simmering water and stir until the gelatin is dissolved. Remove from the heat, and stir in the mayonnaise and the lemon juice. Fold in the onion and crabmeat and set aside.

In a separate bowl, whip the cream until stiff peaks form. Fold the crab mixture into the whipped cream and season with salt and pepper. Pour into a 1-quart loaf pan or mold coated with nonstick cooking spray. Chill the mousse overnight, or until firm. When ready to serve, loosen the edges of the mousse from the pan with a knife and turn out onto a serving plate. Serve with your favorite crackers or toast.

Asparagus Quiche

Crust

1 1/2 cups instant flour (Wondra brand recommended)

1/2 cup (1 stick) unsalted butter, cut into pieces

3 tablespoons vegetable shortening

1/3 cup ice water

Filling

3 large eggs

1 1/4 cups heavy cream

1/4 cup fresh parsley leaves, chopped

1/2 teaspoon salt

Fresh ground white pepper

7 to 8 stalks asparagus, bottoms trimmed

3 tablespoons butter

1/2 cup grated Gruyere cheese

To make the crust, place the flour in a large bowl. Using two knives or a pastry cutter, cut the butter and vegetable shortening into the flour until it resembles coarse meal. Add the ice water and salt and mix until the dough comes together. Form the dough into a ball, wrap in wax paper, and refrigerate for 2 hours.

After the dough has chilled, roll out the pastry on a floured surface to a 1/4-inch thickness. Fit the dough into a 9-inch quiche pan. Use a fork to press the dough around the edges. Refrigerate for 1 hour.

Preheat the oven to 425 degrees F.

Prick the bottom of the pie shell liberally with a fork. Place a sheet of foil in the shell and fill with dried beans, rice, or pie weights. Bake for 5 to 7 minutes, or until the shell begins to feel firm. Remove the pie weights, return the shell to the oven, and bake for another 2 minutes. Use a fork to prick the pie shell, which will be lightly browned and puffed up. Remove from the oven and set aside on a wire rack to cool slightly. Leave the oven at 425 degrees F.

To make the filling, mix together the eggs, cream, parsley, salt, and white pepper in a medium-size bowl. Chill for at least 30 minutes, or cover tightly and refrigerate for up to 1 day. Pour one-third of the egg mixture into the partially baked quiche crust. Bake for 10 minutes, or until the filling begins to set.

While the quiche is baking, cut the asparagus stalks in half. Melt 2 tablespoons butter in a medium skillet over medium heat. Add the asparagus and cook for 4 to 6 minutes, or until tender. The tips will cook faster than the bottoms, so remove them first. Season with salt and black pepper and arrange the asparagus in the quiche pan in a decorative pattern. Pour the rest of the egg mixture over the asparagus. Sprinkle with the Gruyere cheese and dot with the remaining 1 tablespoon butter. Bake for 30 minutes, or until the pastry is puffed and brown. Serve hot or at room temperature.

Rosemary Salmon

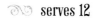 serves 4 to 6

2 large bunches fresh rosemary
1 large red onion, thinly sliced
1 (2-pound) center-cut salmon filet, skin on
Salt
Fresh ground black pepper
2 large lemons, thinly sliced
1/2 cup extra virgin olive oil

Preheat the oven to 500 degrees F.

Arrange half of the rosemary in the center of a heavy baking dish. Arrange half of the onion on top of the rosemary and place the salmon, skin-side down, in the dish. Add the salt and pepper and cover with the remaining onion and rosemary. Place the lemon over the top and drizzle with oil. Roast for 20 minutes, or until flaky and the internal temperature reaches 130 degrees F. Serve hot.

Coconut Pound Cake

serves 12

6 large eggs
1 cup vegetable shortening
1/2 cup (1 stick) unsalted butter, room
 temperature
3 cups sugar
1/2 teaspoon almond extract
1/2 teaspoon coconut extract
3 cups cake flour, sifted
1 cup milk
2 cups packaged or fresh flaked coconut

Preheat the oven to 300 degrees F. Grease and flour a 10-inch tube pan.

Separate the eggs. Set the whites aside and allow them to come to room temperature. Beat the egg yolks with the shortening and butter at high speed until well blended. Gradually add the sugar, beating until light and fluffy. Add the extracts and beat. At low speed, beat in the flour, one-quarter at a time, alternating with the milk, about one-third at a time. Begin and end with the flour. Add the coconut and beat on medium speed until well blended.

In a clean bowl, beat the egg whites until stiff peaks form. Gently fold the whites into the batter. Pour the batter into the prepared pan. Bake for 2 hours.

Remove the cake from the oven and cool in the pan on a wire rack for 15 minutes. Remove from the pan and finish cooling on a rack before slicing and serving.

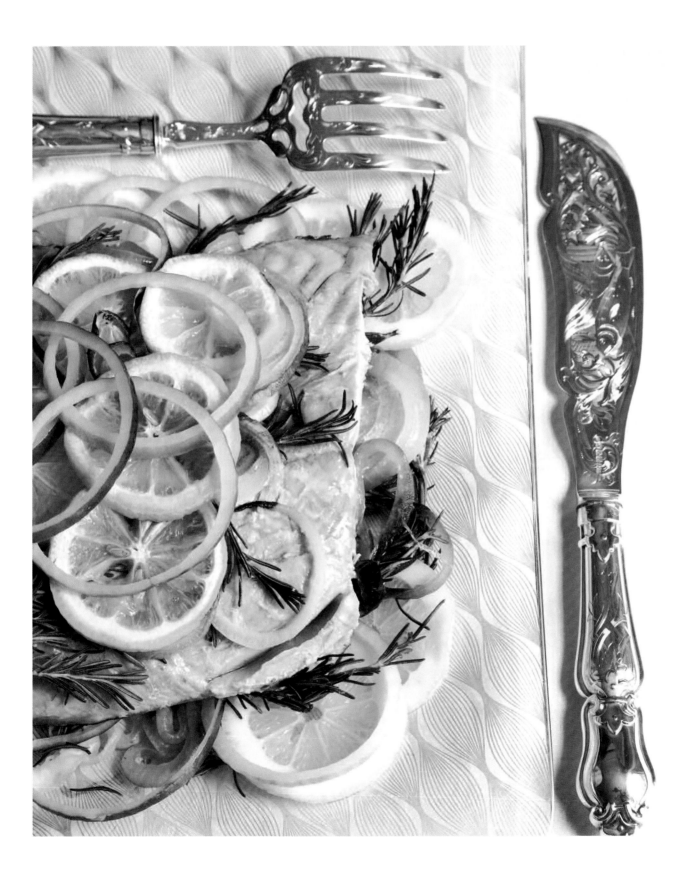

Springtime Sonata

MENU BY
John Nichols

Composed Salad of Prosciutto and
Melon with Fresh Figs
and Balsamic Vinaigrette

Grilled Black Grouper with
Tomato Basil Concasse and Jasmine Rice

Fresh Steamed Asparagus with
Lemon Zest and Sauce Choron

Ricotta with Fresh Berries in
Citrus Syrup with Vanilla Croutons

Kahlil Gibran
(Lebanese, 1883-1931)
Rose Sleeves, 1911
Oil on canvas, 25 3/8 x 18 in.
(64.5 x 45.7 cm)
Gift of Mary Haskell Minis

Rose Sleeves, painted by the famed author of *The Prophet*, clearly demonstrates the influence of the Pre-Raphaelites, especially Dante Gabriel Rossetti (1882 -1882). Like British painter J. M. W. Turner, whose work the budding artist admired, Gibran used layered, unblended colors. Gibran's short career as an oil painter resulted in the five oil on canvas paintings comprising a part of the Telfair's collection of his work. The work suggests a fantasy of swirling color and lyrical vibrations, evoking a mood suitable for a meal of the rich, colorful flavors of figs, melon and citrus as a prelude to a musical evening.

Composed Salad of Prosciutto and Melon with Fresh Figs and Balsamic Vinaigrette

≈ serves 6

Balsamic Vinaigrette

3 tablespoons balsamic vinegar
1/2 teaspoon Dijon mustard
Salt
Fresh ground pepper
9 tablespoons extra virgin olive oil

Salad

5 ounces baby arugula
1 large cantaloupe, cut into melon balls
2 ounces thinly sliced prosciutto, torn
 into strips
6 to 8 fresh figs, stemmed, and each cut
 into 6 pieces
8 ounces Parmigiano-Reggiano, for shaving
1 bunch basil leaves

To make the dressing, whisk together the vinegar, mustard, salt, and pepper. Slowly whisk in the olive oil until the mixture is emulsified. Refrigerate the dressing until ready to serve.

Place the arugula in a large bowl and toss with 3 tablespoons of the vinaigrette. Place a serving of the salad in the center of each serving plate. Top with the melon balls and torn strips of prosciutto. Arrange the figs and the shavings of Parmigiano-Reggiano on and around the salad. Sprinkle with a few basil leaves and drizzle with additional vinaigrette to taste before serving.

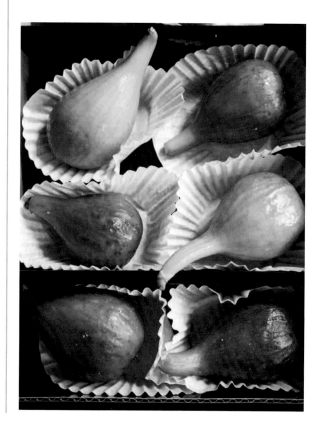

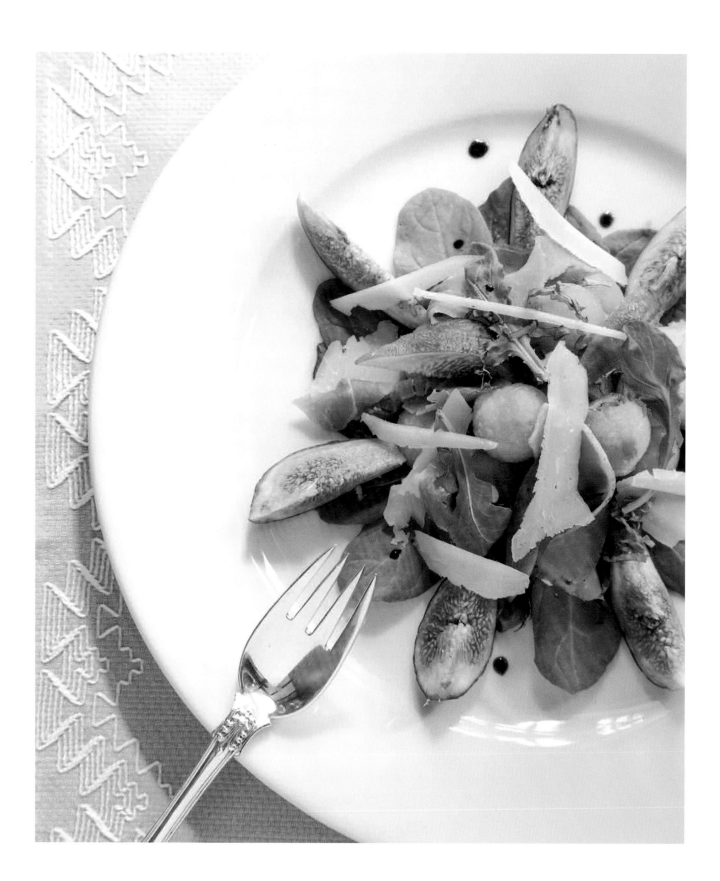

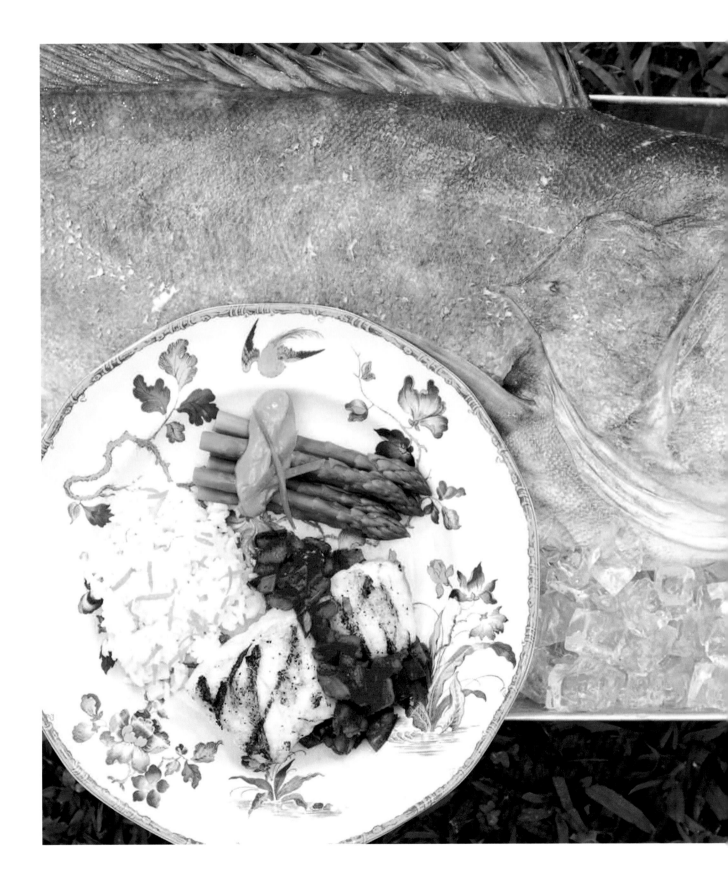

Grilled Black Grouper with Tomato Basil Concasse and Jasmine Rice

❧ serves 6

Tomato Basil Concasse
3 large tomatoes, seeded and chopped
3 teaspoons extra virgin olive oil
1 1/2 teaspoons balsamic vinegar
1/3 cup fresh basil, finely chopped
Salt
Pepper

Grouper
6 (6-ounce) black grouper filets
Olive oil
Salt
Pepper

Jasmine Rice
1 cup jasmine rice, uncooked
Zest of 1 orange
2 tablespoons fresh parsley, chopped

Combine the tomatoes, olive oil, balsamic vinegar, and basil in a bowl. Season with salt and pepper to taste, cover, and set aside in a cool place.

Heat a grill to medium heat. Brush the fish with olive oil and season with salt and pepper. Place the fish on the grill, flesh-side down, to create grill marks. Turn the fish to cook skin-side down for 7 minutes, or until the fish is cooked through.

Prepare the jasmine rice according to the package directions. When the rice is done cooking, add the fresh orange zest and chopped parsley and toss with a fork.

Transfer the fish to a dinner plate. Spoon the tomatoes over the fish, spoon a side of rice onto the plate, and serve.

Fresh Steamed Asparagus with Lemon Zest and Sauce Choron

୬୬ serves 6

Tarragon Reduction
1/4 cup tarragon vinegar
1/4 cup dry white wine
1 tablespoon shallots, minced
1 tablespoon dried tarragon
Salt
Pepper
2 tablespoons fresh tarragon, minced

Sauce Choron
3 egg yolks
Salt
Pinch black pepper
1/2 cup (1 stick) butter, cut into small pieces
2 tablespoons tomato paste

1 1/2 pounds fresh green asparagus
Sea salt
Fresh ground pepper
Zest of 1 lemon

To make the tarragon reduction, combine the vinegar, wine, shallots, and dried tarragon in a small saucepan over moderate heat. Bring to a simmer and reduce for 10 minutes, or until 2 tablespoons of liquid remain. Cool the mixture and strain through a fine sieve. Add the salt, pepper, and minced tarragon and stir well. Set aside.

To make the sauce choron, combine the egg yolks, salt to taste, pepper, and 1 tablespoon of the tarragon reduction in a blender. Set aside.

In a small saucepan over medium-high heat, add the butter and heat until it foams.

Blend the egg yolk mixture at high speed for 2 seconds. With the blender running, remove the cover and add the hot butter in a thin stream. The sauce will become a thick cream after two-thirds of the butter has been added. Add the rest of the butter, except for the milky residue at the bottom of the pan. Add in the tomato paste and adjust the seasoning. If not using the sauce immediately, set the blender carafe aside in tepid, but not warm, water.

To steam the asparagus, wash and trim the woody ends off the bottom of the stalks. Place the asparagus in a pan with 1/2 cup water, cover, and cook on high for 2 to 3 minutes, or until the asparagus is bright green and tender. Cooking time will vary depending on the thickness of the stalks. Season the asparagus with salt and pepper.

Serve the sauce choron over the steamed asparagus and garnish with the lemon zest.

Ricotta with Fresh Berries in Citrus Syrup with Vanilla Croutons

Vanilla Sugar
1 vanilla bean, cut and scraped, or
 1 teaspoon vanilla extract
2 cups sugar

Vanilla Croutons
1/2 loaf ciabatta, cut into 1-inch cubes
1/2 pound (2 sticks) unsalted butter, melted
2 tablespoons Vanilla Sugar

Fresh Berries in Citrus Syrup
3/4 cup fresh orange juice
1/2 cup fresh lemon juice
3/4 cup sugar
1 cup blueberries
1 quart fresh strawberries

Ricotta
3 cups whole milk ricotta cheese
Zest of 2 oranges
2 teaspoons lemon zest
2 tablespoons vanilla sugar

Mint leaves, for garnish

To make the vanilla sugar, bury the vanilla bean and its seeds in 2 cups of sugar. Place the sugar in an air-tight jar and store for 1 to 2 weeks. Or, mix the vanilla extract in 2 cups of sugar and spread the sugar in a thin layer over a cookie sheet. Allow the sugar to dry for 5 hours.

Preheat the oven to 400 degrees F. In a bowl, toss together the bread cubes and the butter. Add 2 tablespoons of the vanilla sugar and toss until the bread cubes are coated.

Line a baking pan with parchment paper and place the bread cubes on the pan in a single layer. Bake for 10 minutes, or until golden brown.

Bring the orange juice, lemon juice, and sugar to a simmer in a medium saucepan over medium-low heat. Cook for 2 to 3 minutes, or until the sugar dissolves. Add the blueberries and strawberries and simmer for 3 to 4 minutes, or until the fruit softens. Remove the berries from the heat and allow them to cool to room temperature.

Combine the ricotta cheese, orange and lemon zest, and vanilla sugar in a bowl and mix well. Refrigerate until ready to serve.

To serve, divide the ricotta mixture evenly among 6 dessert bowls. Spoon the fruit and syrup over the ricotta and add the croutons. Garnish with mint and serve.

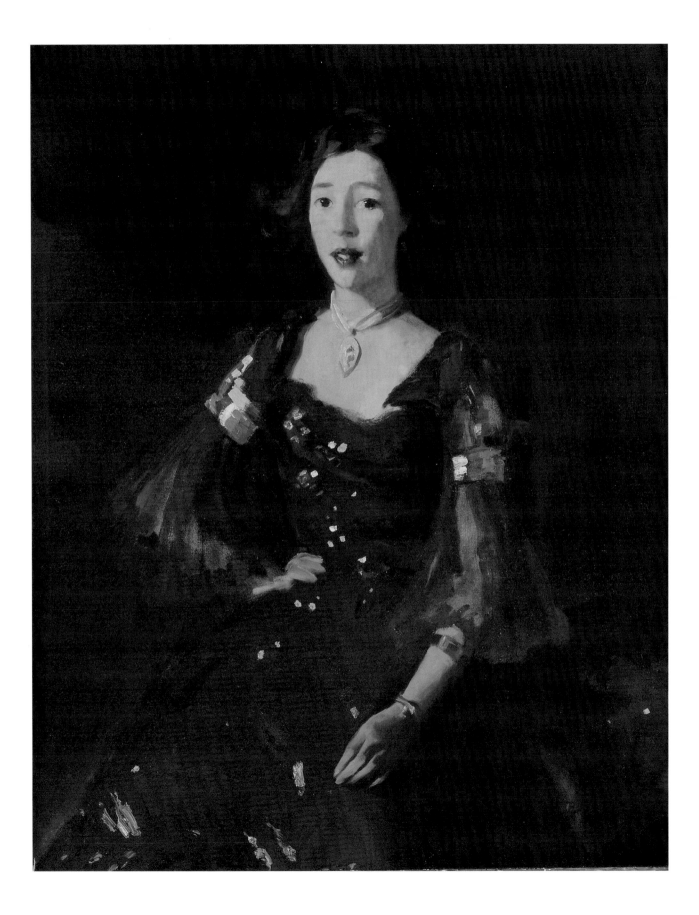

Crustaceans And Castanets

MENU BY
The Committee

Robert Henri
(American, 1865-1929)
La Madrileñita (The Girl of Madrid), 1910
Oil on canvas, 41 x 33 3/16 in.
Museum purchase 1919.1

Robert Henri, generally considered one of America's most influential painters of the early twentieth century, is also widely known for his role as a teacher and one of the leaders of the Eight. Renowned for his portraits, Henri often traveled from his New York base in search of subjects for his paintings, and Spain was a frequent destination. This dazzling portrait of Josefa Cruz, a young Spanish dancer, was purchased for the Telfair's collection by Gari Melchers in 1919. At the time of the purchase, Henri stated:

> I take great pleasure in the honor of having one of my pictures in the Telfair collection, and I feel that you will have in the picture "Madrileñita" one of the very best things I have painted... It was painted in Madrid. She is a very young girl born and raised a dancer (that is, she is the niece of the celebrated teacher of dancing, Cansino, of Madrid). Cansino trained her in the old dances of Spain. Although very young she was already a very remarkable dancer at the time the painting was done, and it seemed to me she had in her carriage... much of the spirit and dignity of old Spain.

The large number of Spanish subjects in his oeuvre attests to Henri's ongoing fascination with Spain's spirited citizens, sunny climate, and ancient culture. *La Madrileñita* brings to mind the musical Zarzuela and Spanish seafood stew of the same name.

Sangria

Banderillas

Zarzuela (Spanish Shellfish Stew)
with Roasted Sausage

Spanish Orange Onion Salad

Blood Orange Flan

(suggested accompaniment)
Batard of Black Olive Bread

Sangria

∽∾ serves 6 to 8

1 bottle Spanish Rioja, or dry red wine

1/2 cup Applejack Brandy

1/2 cup orange-flavored liqueur (Triple Sec,
 Grand Manier, or Cointreau)

1/4 cup lemon juice

1/2 cup orange juice

1/3 cup frozen lemonade concentrate

1 to 2 tablespoons superfine sugar, or to taste

1 lemon, thinly sliced into rounds

1 orange, thinly sliced into rounds

1 lime, thinly sliced into rounds

1 green apple, cored, and cut into thin wedges

2 peaches, pitted, and cut into thin wedges

2 to 3 cups chilled club soda, ginger ale,
 or sprite (optional)

Combine the wine, brandy, orange liqueur, lemon juice, orange juice, lemonade concentrate, and sugar to taste and stir well. Place the fruit in a large glass pitcher and pour the wine mixture over the fruit. Cover and refrigerate at least 2 to 3 hours, or until well chilled.

Place some of the marinated fruit in the bottom of a well-chilled wine glass. Fill the glass 2/3 full of Sangria and top with a hearty splash of club soda. Garnish with a slice of fresh orange or wedge of fresh peach.

Or, if desired, add 2 to 3 cups of chilled club soda, ginger ale or sprite into the pitcher and stir. Pour into chilled glasses, and garnish with the marinated fruit. Sangria may be served over ice if desired.

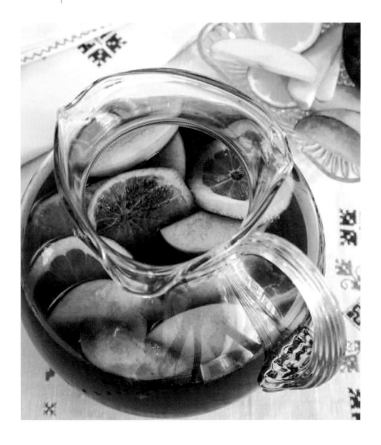

Banderillas

yields 2 dozen

Dressing

3 tablespoons parsley, finely minced

3 tablespoons dill pickles or cornichon pickles, finely minced

3 cloves garlic, finely minced

3 tablespoons olive oil

Small Bites

1 small jar cornichon, or midget dill pickles, halved

1 small jar cocktail onions

1 can solid white tuna

1 small jar stuffed green olives

1 small jar pitted, cured black olives

1 small jar pimientos

1 small can hearts of palm, cut into 1/4-inch rounds

20 small shrimp, deveined, cooked, and peeled

Banderillas are small bites served on cocktail skewers or toothpicks, using a variety of ingredients. They are usually eaten in one bite so that all the flavors are savored together.

To make the dressing, place the parsley, pickle, and garlic in a food processor, gradually add the olive oil, and blend until smooth. Arrange the ingredients 4 to 6 to a skewer. The dressing can be served on the side or drizzled over the skewers. The skewers may be assembled, covered, and refrigerated 1 to 2 hours prior to serving.

Be creative! Mix and match your own favorite ingredients, such as green or black olives, hearts of palm, pimiento, shrimp, artichokes, or rolled anchovy.

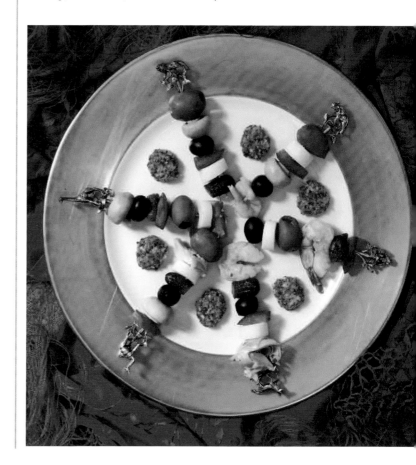

Zarzuela (Spanish Shellfish Stew) with Roasted Sausage

serves 6 to 8

8 ounces Spanish chorizo sausage

8 ounces sweet Italian sausage

3 tablespoons extra virgin olive oil

2 teaspoons anchovy paste

1 cup onions, finely chopped

1 cup (about 2 small) red and yellow sweet
 bell peppers, finely chopped

2 tablespoons garlic, finely chopped

2 tablespoons prosciutto or Serrano ham,
 finely chopped

1 (14 1/2-ounce) can diced seasoned tomatoes,
 juices reserved

1/2 cup blanched almonds, ground

1 large bay leaf, crumbled

1 teaspoon dried basil

1 teaspoon dried oregano

15 grindings black pepper, or to taste

1 cup dry white wine

1 tablespoon fresh lemon juice

1/8 teaspoon ground Spanish saffron or
 saffron threads, crushed and
 dissolved in a little hot water

3 cups chicken stock, clam broth, seafood stock,
 or lobster base, or any combination liquid

Sea salt

24 clams, washed and thoroughly scrubbed

24 mussels, washed, scrubbed, and black
 tufts removed

12 to 24 large shrimp, peeled, deveined,
 and washed, tails on

1/2 pound sea scallops, halved

12 snow crab claws or pieces of king crab,
 in the shell

Chopped flat-leaf parsley, for garnish

Preheat the oven to 350 degrees F. Place the sausages on a baking sheet and roast for 45 minutes, or until the sausages are cooked through. Remove the sausages from the oven and set aside.

Soak the scrubbed mussels and clams in a cold water bath, with a heavy sprinkling of cornmeal, for 30 minutes. Rinse well.

Heat a heavy 6 or 8-quart flameproof casserole dish over moderate heat. Add the olive oil, and then add the anchovy paste, onions, garlic, and sweet bell peppers. Cook, stirring frequently, for 5 minutes or until the vegetables are soft but not brown. Stir in the ham and cook for 1 minute. Add the tomatoes, almonds, bay leaf, basil, oregano, and 10 to 15 grindings of pepper. Cook over high heat for 5 minutes, or until the mixture is thick enough to hold its shape lightly in a spoon. Add the wine, lemon juice, dissolved saffron, and stock (if using lobster base, it must be reconstituted in boiling water before use). Add the reserved tomato juice and sea salt if desired. Bring the mixture to a boil and simmer for a few minutes to let the flavors develop. You can store this mixture in a covered container in the refrigerator for up to a day ahead and reheat it to serve.

When ready to serve, slice the sausages in round chunks and bring the stew back up to temperature. Add the clams and mussels, cover the pot tightly, reduce the heat to moderate, and cook for 10 minutes. Add the shrimp, scallops, and crab claws, cover, and cook 5 minutes more. Stir in the sausage and discard any clams or mussels that have not opened. Adjust the seasoning to taste, sprinkle with parsley, and serve with a batard of black olive bread for dipping.

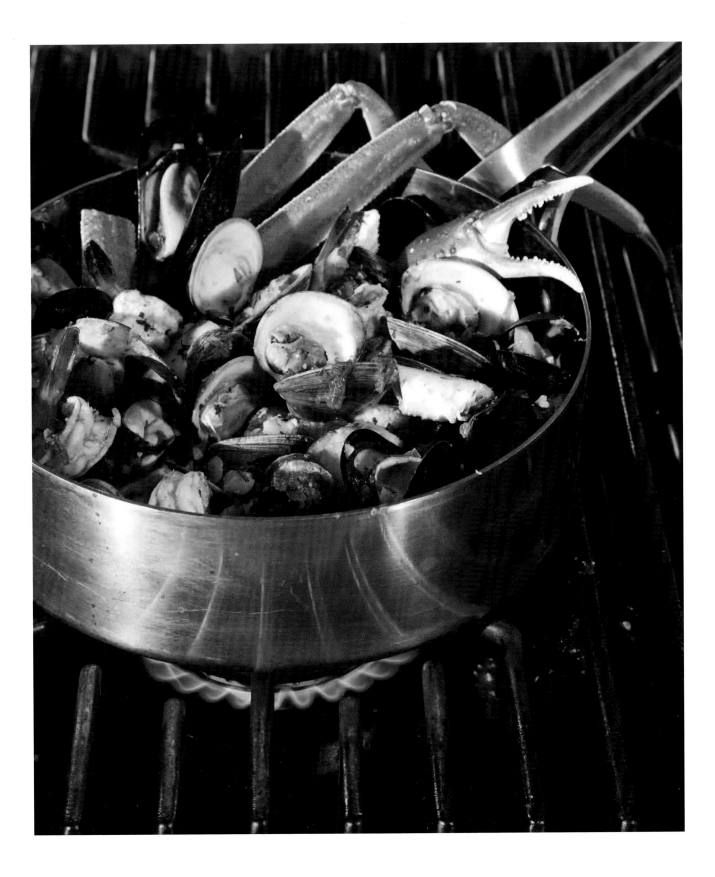

Spanish Orange Onion Salad
serves 6

6 seedless oranges or blood oranges,
 peeled and sliced into1/4-inch rounds
1 red onion, halved and thinly sliced
1 medium banana pepper, chopped
1 small bunch flat-leaf parsley, roughly chopped
1 bunch arugula
9 ounces Manchego cheese, shaved or cubed
Extra virgin olive oil
Sea salt
Fresh ground pepper
Smoked paprika

Arrange the orange slices on each salad plate and sprinkle them with the onion, chopped banana peppers, and chopped parsley. Top the oranges with arugula and the Manchego cheese. Before serving, drizzle liberally with extra virgin olive oil and season with sea salt, fresh ground pepper, and smoked paprika to taste.

Blood Orange Flan

Caramel

2/3 cup sugar

1/4 cup water

1/4 cup fresh squeezed blood orange juice, strained

Custard

1 (14-ounce) can sweetened condensed milk

2 cups heavy cream

1 cup milk

5 eggs

2 teaspoons vanilla extract

1 tablespoon orange zest, finely minced

Blood orange segments, for garnish

Fresh mint, for garnish

Simmer the sugar and water in a medium-size, non-reactive saucepan, without stirring, over medium-high heat for 10 minutes, or until the syrup begins to turn an amber-caramel color. Swirl the pan occasionally to cook the sugar evenly. Do not over-brown the caramel.

Remove the pan from the heat, allow the bubbles to subside, then add the orange juice to the pan very slowly, stirring with a wooden spoon, or whisking constantly. When the juice is thoroughly combined, pour the caramel into an ungreased 1 1/2-quart straight-sided soufflé dish, or 8 (6-ounce) ungreased ramekins. Cover the bottoms of the ramekins or the dish with the hot caramel to a depth of 1/4-inch and swirl to coat, if necessary. Allow the caramel to cool and harden for 15 minutes.

Preheat the oven to 350 degrees F.

In a blender, combine the sweetened condensed milk, cream, milk, eggs, vanilla, and orange zest and blend on high speed for 1 minute. Pour the mixture over the cooled prepared caramel, and place the ramekins or souffle dishes in a small roasting pan. Pour enough water into the bottom of the pan to come halfway up the sides of the dishes. Place the roasting pan in the oven and bake the ramekins for 30 to 45 minutes (or bake a large souffle dish for 70 to 75 minutes), or until a knife inserted in the center of the flan comes out clean. Remove the roasting pan from the oven, carefully remove the ramekins or souffle dish, and cool on a wire rack. Refrigerate for 12 hours. After the first hour of cooling, wrap the souffle dishes or ramekins with plastic wrap.

To serve, run a knife around the inside edge of the dish. Hold a serving dish over the top of the ramekin and invert to unmold the flan. Garnish with segments of blood orange and a mint sprig.

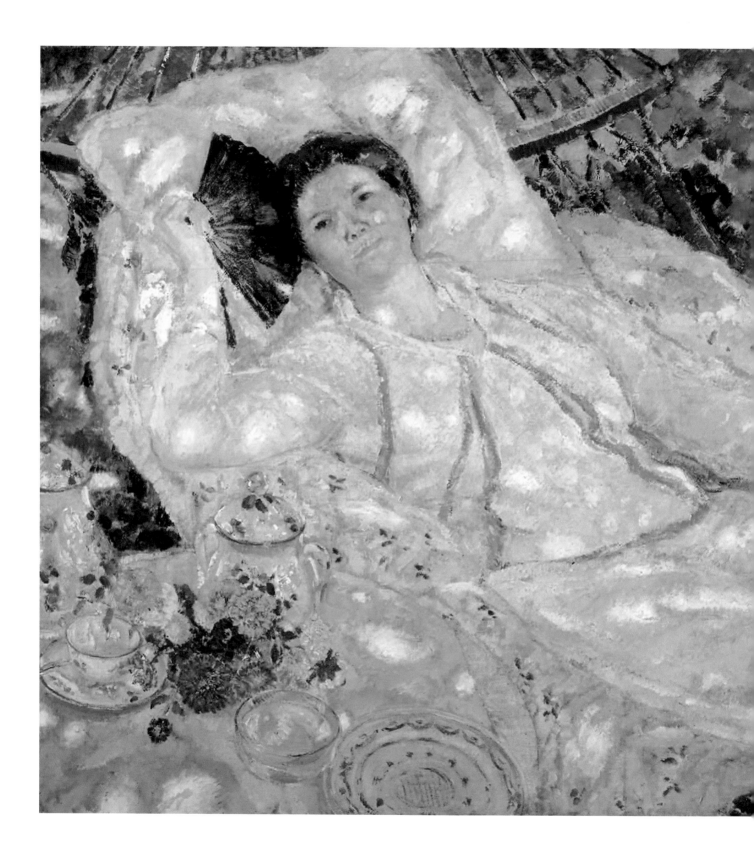

F.C. Frieseke.

Summer

The Boating Party
Menu by The Starland Dining Group

Flying Flags
Menu by Paula Deen

Middle Eastern Feast
Menu by Cynthia Creighton-Jones

Lazy Days
Menu by Trish McLeod
and John Nichols

Frederick Carl Frieseke
(American, 1874-1939)
The Hammock, by 1915
Oil on canvas, 38 5/8 X 51 5/8 in.
(98.1 X 131.1 cm)
Museum purchase 1917.3

Sunlight, with all its varied and transformative effects, is the subject of Frederick Carl Frieseke's painting, *The Hammock*. The artist was drawn from his native Michigan to Paris, a mecca for art students in the late nineteenth century, then later settled in Giverny, the artist's colony surrounding Monet. There he perfected his decorative style of impressionism characterized by loose brushwork and a highly patterned surface.

The heat of the day is conveyed by the sun's dappling of the artist's wife Sadie as she fans herself while lounging in the hammock. The dominance of blues and violets create by contrast a coolness and calm.

The Hammock suggests summer's lazy days, filled with boating parties and picnics, with fireworks and regattas, keeping the heat at bay.

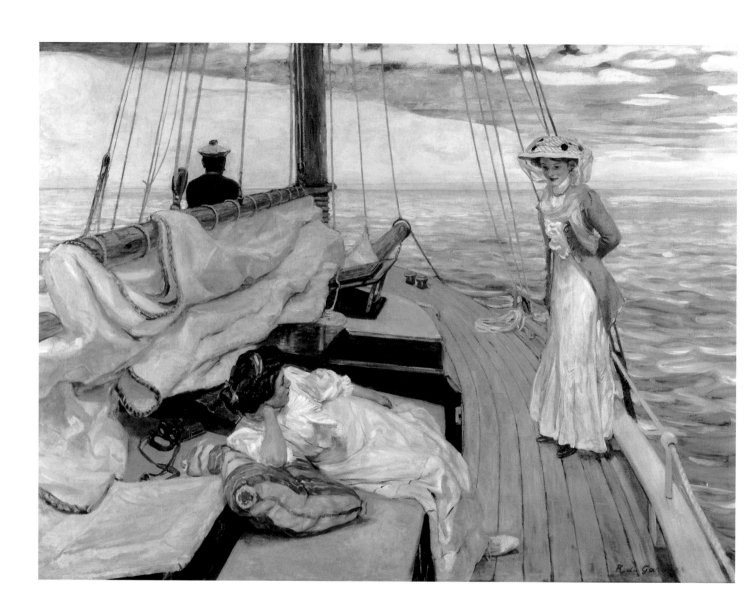

Raoul du Gardier
(French, b. Germany, 1871-1952)
Calme blanc (White Calm),
c. 1900-1909
Oil on canvas, 55 x 78 in.
(141.6 x 198.1 cm)
Museum purchase 1909.1

In *Calme blanc* (White Calm), Raoul du Gardier
utilizes the loose brushstrokes and light-infused
color palette of the French impressionists to portray
a pleasant scene of privileged leisure. Du Gardier
studied in Paris under traditional academic painters
but by the start of the twentieth century, he had es-
chewed the historical subjects espoused by the
French academic establishment, choosing instead
to focus on scenes of contemporary life such as the
tranquil boating scene depicted in *Calme blanc*. His
technical skill is evident in his successful applica-
tion of a demanding white-on-white color scheme:
the crispness of the ladies' white dresses, the com-
paratively dingy whiteness of the idle sails, and the
blanket of clouds whose gray-white reflection tem-
pers the choppy azure waves of the sea. Purchased
for the Telfair by Gari Melchers in 1909, the painting
is composed in such a way that it seems to invite
the viewer to step onto the yacht's deck to join this
elegant boating party for an idyllic summer outing
on the open water.

The Boating Party

MENU BY
The Starland Dining Group

Rosemary Ham, Fig, and Goat Cheese Batard

Cannellini Bean Hummus on Crostini

Edamame Salad

Savannah Shrimp Salad Lettuce Cups

Summer Fingerling Potato Salad

Toasted Orzo, Peas, and Parmesan Salad

Fresh Fruit Tart

Dutch Chocolate Brownies with
Hot Pepper Raspberry Glaze

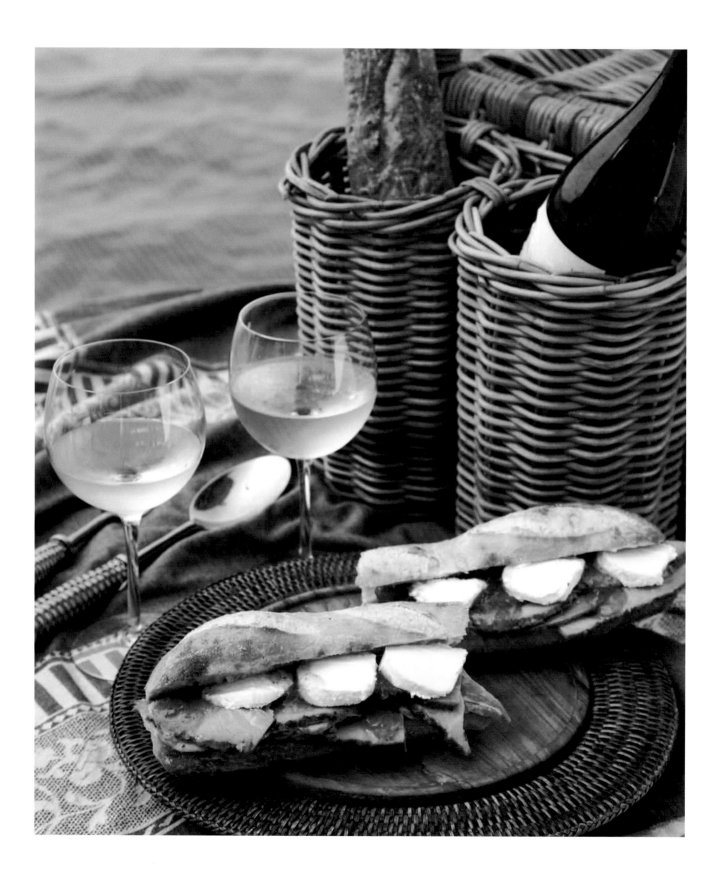

Rosemary Ham, Fig, and Goat Cheese Batard

serves 2

1 torpedo-shaped baguette or batard
3/4 pound Boar's Head Rosemary Ham,
 thinly sliced
1 jar fig jam
6 ounces goat cheese

Cut the baguette or batard evenly into two 6-inch portions and split each open lengthwise. Place the ham evenly over one half of each portion and spread the fig jam and goat cheese over the opposite side as desired. Serve with your favorite chilled white wine.

Cannellini Bean Hummus on Crostini

yields 20

Crostini
1 large baguette or thin Italian loaf (2 1/2 to
 3 inches in diameter)
1 large clove garlic, peeled
Salt
Pepper

Hummus
1 (15-ounce) can cannellini beans, drained,
 rinsed, and patted dry
4 tablespoons extra virgin olive oil, divided
2 tablespoons dry Sherry or water
1 tablespoon fresh squeezed lemon juice,
 or to taste
1 medium clove garlic, crushed
1 tablespoon packed fresh parsley leaves

Garnish (optional)
Parmesan or Romano cheese, finely grated
Fresh sage, chopped

Adjust the oven rack to the middle position and preheat the oven to 400 degrees F. Cut the baguette on the bias into 1/2-inch-thick slices, yielding about 20 slices. Arrange the bread slices in a single layer on a baking sheet and bake for 8 to 10 minutes, or until the bread is dry and crisp, turning the slices over halfway through baking.

While the crostini are in the oven, process two-thirds of the cannellini beans with 2 tablespoons olive oil, Sherry, lemon juice, garlic, and parsley in the work bowl of a food processor for 10 seconds, or until smooth. Scrape down the sides of the work bowl, add the remaining beans, and pulse just to incorporate—about five 1-second pulses. Do not make the puree completely smooth.

Remove the crostini from the oven and rub the raw garlic clove over each slice of bread while it is still hot. Season the crostini with salt and pepper to taste. The crostini are best straight out of the oven, but they can be set aside for several hours before serving. To serve, spread the hummus over the bread slices and drizzle the remaining 2 tablespoons olive oil over the crostini, or serve with your favorite pita chips or fresh vegetables.

Edamame Salad

serves 6

1 pound frozen edamame, shelled

2 tablespoons kosher salt

1 shallot, minced

4 ounces canned corn, drained

4 ounces jarred fire-roasted or sundried
 tomatoes, chopped

1 tablespoon olive oil

2 tablespoons fresh basil, chopped

2 tablespoons fresh parsley, chopped

1/4 cup crumbled feta cheese

Juice of 1 lemon

Salt and pepper

8 ounces silken tofu, cubed (optional)

Fill a large bowl with cold water and set aside.

Cook the edamame as directed on the package, taking care not to overcook. Drain the edamame in a colander and transfer them to the bowl of cold water to stop the cooking process. Keep the edamame in the water for just a few seconds if you want to serve the salad warm, longer if you want to serve it at room temperature. Drain the edamame again and spread them onto a sheet tray lined with paper towels to dry. If desired, sprinkle with kosher salt to taste.

Place the edamame in a medium-sized mixing bowl. Add the shallot, corn, tomato, olive oil, and fresh herbs. Toss together with the crumbled feta and lemon juice and adjust the salt and olive oil to taste. Stir in the tofu last, if desired. Refrigerate the salad until ready to serve.

For best results, allow the flavors to develop in the refrigerator overnight. As a variation, cilantro or rosemary can be substituted for the basil.

Savannah Shrimp Salad Lettuce Cups

Shrimp

1 pound (21 to 25) extra-large shrimp, peeled
and deveined, with tails removed
1/4 cup fresh squeezed lemon juice, used
lemon halves reserved
5 sprigs fresh parsley leaves
3 sprigs fresh tarragon leaves
1 teaspoon whole black peppercorns
1 tablespoon light brown sugar
1 teaspoon salt
2 cups cold water

Dressing

1 teaspoon dried chipotle pepper, ground
1/4 cup mayonnaise
1 small shallot, finely minced
1 small stalk celery, minced
1 tablespoon fresh squeezed lemon juice
1 teaspoon fresh parsley leaves, minced
1 teaspoon fresh tarragon leaves, minced
Salt
Ground black pepper

Boston Bibb lettuce

Garnish (optional)

1 avocado, chopped
Fire-roasted or sundried tomato
Blue cheese
Corn
Watercress, cilantro, or basil

Bring the shrimp, 1/4 cup lemon juice, reserved lemon halves, parsley sprigs, tarragon sprigs, whole peppercorns, sugar, salt, and 2 cups cold water to a simmer in a medium saucepan over medium heat, cook 8 to 10 minutes, or until the shrimp are just pink. Meanwhile, fill a medium bowl with ice water.

Drain the cooked shrimp into a colander and discard the lemon halves, herbs, and spices from the saucepan. Immediately transfer the shrimp to the ice water to stop the cooking. Chill for 3 minutes. Remove the shrimp from the ice water and pat dry with paper towels. Set aside, or you may store, covered, in the refrigerator for up to 2 days.

Whisk together the dried chipotle, mayonnaise, shallot, celery, lemon juice, parsley, and tarragon in a medium bowl. Cut the shrimp into bite-size pieces. Add the shrimp to the mayonnaise mixture and toss to combine. Season the shrimp with salt and pepper to taste.

Scoop the salad into the Boston Bibb lettuce cups and garnish the lettuce cups with chopped avocado, fire-roasted or sundried tomato, blue cheese, corn, fresh herbs, or your favorite toppings.

Summer Fingerling Potato Salad

〰 **serves 6 to 8**

Vinaigrette

1 tablespoon Dijon mustard

1 tablespoon Sherry wine vinegar

1/4 cup olive oil

1 teaspoon fresh Italian parsley, chopped

1 teaspoon fresh tarragon, chopped

Fine sea salt

Freshly ground black pepper

Salad

2 cups coarse sea salt

2 pounds fingerling potatoes

2 slices Applewood-smoked bacon, cut
 crosswise into 1/4-inch-thick strips

2 small shallots, thinly sliced

2 hard-boiled eggs, peeled and chopped

2 green onions, thinly sliced

Garnish (optional)

1 hot house cucumber, sliced

1 small jar sliced pickled beets

To make the vinaigrette, combine the mustard and vinegar in a small bowl. Whisk in the oil, then the parsley and tarragon. Season with sea salt and pepper to taste. Set aside.

For the potatoes, preheat the oven to 400 degrees F. Spread the 2 cups sea salt in an even layer on a rimmed baking sheet. Arrange the potatoes over the salt, spacing them slightly apart. Cover the baking sheet with foil and bake for 1 hour, or until the potatoes are tender. Remove the potatoes from the oven, uncover, and cool until lukewarm. Meanwhile, cook the bacon in a skillet over medium heat until it becomes brown and crisp. Transfer the bacon to paper towels to drain.

When the potatoes are cool enough to handle, peel and cut them in half lengthwise. Place the warm potatoes in a medium bowl. Add the bacon, shallots, eggs, onions, and vinaigrette and toss well. Serve on a platter surrounded by slices of cucumber and pickled beets.

Toasted Orzo, Peas, and Parmesan

serves 6 to 8

2 tablespoons (1/4 stick) unsalted butter
1 medium onion (1 cup), finely chopped
3/4 teaspoon sea salt, plus more to taste
2 medium cloves (2 teaspoons) garlic, minced
10 ounces orzo pasta
2 1/2 to 3 cups low sodium chicken broth
1/2 cup dry vermouth or dry white wine
10 ounces (1 3/4 cups) frozen peas
2 ounces (1 cup) Parmesan cheese, grated
Pinch ground nutmeg
Pinch freshly ground black pepper

Garnish (optional)
Chopped arugula
Toasted pine nuts
Grape tomatoes, halved

Heat the butter in a 12-inch nonstick skillet over medium-high heat. When the butter's foaming subsides, add the onion and salt and cook for 5 minutes, stirring frequently, or until the onion has softened and is beginning to brown. Add the garlic and cook until fragrant, about 30 seconds. Add the orzo and cook for 5 to 6 minutes, stirring frequently with a heatproof rubber spatula, or until most of the orzo is lightly browned and golden.

Remove the skillet from the heat and add the vermouth and chicken broth. Return the skillet to medium-high heat and bring the liquid to a boil. Reduce the heat to medium-low and simmer, stirring occasionally, for 10 to 15 minutes, or until all the liquid has been absorbed and the orzo is tender. Stir in the peas, Parmesan, nutmeg, and pepper, and season to taste. Remove from the heat and allow the pasta to stand for 2 minutes, or until the peas are heated through. Add sea salt to taste, garnish as desired, and serve.

Fresh Fruit Tart

☙ **yields 1 (8-inch) tart**

Dough
Flour, for dusting
1 package pre-made pie dough

Fruit Filling
1 pound peaches, nectarines, apricots or plums
1 cup (1/2 dry pint) raspberries, blueberries, or blackberries
3 to 5 tablespoons sugar, plus 1 tablespoon, for sprinkling
1/4 cup water
1/4 cup apricot preserves

Halve and pit the stone fruit and cut into 1/2-inch-thick wedges. Gently wash and dry the berries. Combine the fruit in a medium bowl (you should have about 3 cups). Sprinkle the fruit with 3 to 5 tablespoons of sugar and toss gently to combine. Set aside.

Adjust the oven rack to the lower-middle position and preheat the oven to 350 degrees F. On a large sheet of parchment paper lightly dusted with flour, roll the dough out to a 12-inch round about 3/16-inch thick, dusting with flour as needed.

Mound the fruit in the center of the dough, leaving a 2 1/2-inch border around the edge of the dough. Carefully grasp one edge of the dough and fold it over the outer 2 inches of the fruit mound, leaving a 1/2-inch area just inside the fold of the dough (on the outside perimeter of the tart) that is free of fruit. Repeat this process around the circumference of the tart, overlapping the dough every 2 to 3 inches. Gently pinch the pleated dough to secure, but do not press the dough into the fruit in the center. Working quickly, brush the dough with water and sprinkle evenly with 1 tablespoon sugar. Bake for 45 to 50 minutes, or until the crust is a deep golden brown and the fruit is bubbling.

Remove the tart from the oven and brush the top with 1/4 cup warmed apricot preserves while the tart is still warm. Cool the tart on a baking sheet on a wire rack for 10 minutes. Using an offset metal spatula, loosen the tart from the parchment and carefully slide the tart off the parchment onto the wire rack. Continue to cool the tart until warm, about 30 minutes, or to room temperature, about 1 hour. Cut into wedges and serve.

Dutch Chocolate Brownies with Hot Pepper Raspberry Glaze

yields 16

5 ounces semisweet or bittersweet
 chocolate, chopped
2 ounces unsweetened chocolate, chopped
1/4 cup (1/2 stick) salted butter, quartered
3 tablespoons cocoa powder (Dutch
 processed or natural cocoa)
3 large eggs
1 1/4 cups sugar
2 teaspoons vanilla extract
1/2 teaspoon salt
1 cup unbleached all-purpose flour
1 (8-ounce) jar hot pepper raspberry jelly

Adjust the oven rack to the lower-middle position and preheat the oven to 350 degrees F. Spray an 8-inch square baking pan with nonstick vegetable cooking spray. Fold two (12-inch) pieces of foil lengthwise so that they measure 7 1/2 inches wide. Fit one sheet in the bottom of the greased pan, pushing it into the corners and up the sides of the pan—the overhang will create a handle to help in the removal of the baked brownies. Fit the second sheet in the pan in same manner, perpendicular to the first sheet. Spray the foil with nonstick cooking spray.

Melt the chocolates and butter in the microwave in a medium-sized, heatproof bowl, stirring occasionally until the mixture is smooth. Whisk in the cocoa until smooth. Set the mixture aside to cool slightly.

Whisk together the eggs, sugar, vanilla, and salt in a medium bowl until combined. Whisk the warm chocolate mixture into the egg mixture, then stir in the flour with a wooden spoon until just combined. Pour the mixture into the prepared pan, spreading it into the corners, and level the surface with a rubber spatula. Bake for 35 to 40 minutes, or until the brownies are slightly puffed and a toothpick inserted in the center comes out with a small amount of sticky crumbs clinging to it. Cool on a wire rack to room temperature, about 2 hours, then remove the brownies from the pan using the foil handles.

Warm the hot pepper raspberry jelly by removing the metal lid and heating the jar in the microwave for 10 seconds. Spread the warmed jelly over the top of the brownies with a spoon and cut into 1-inch squares to serve.

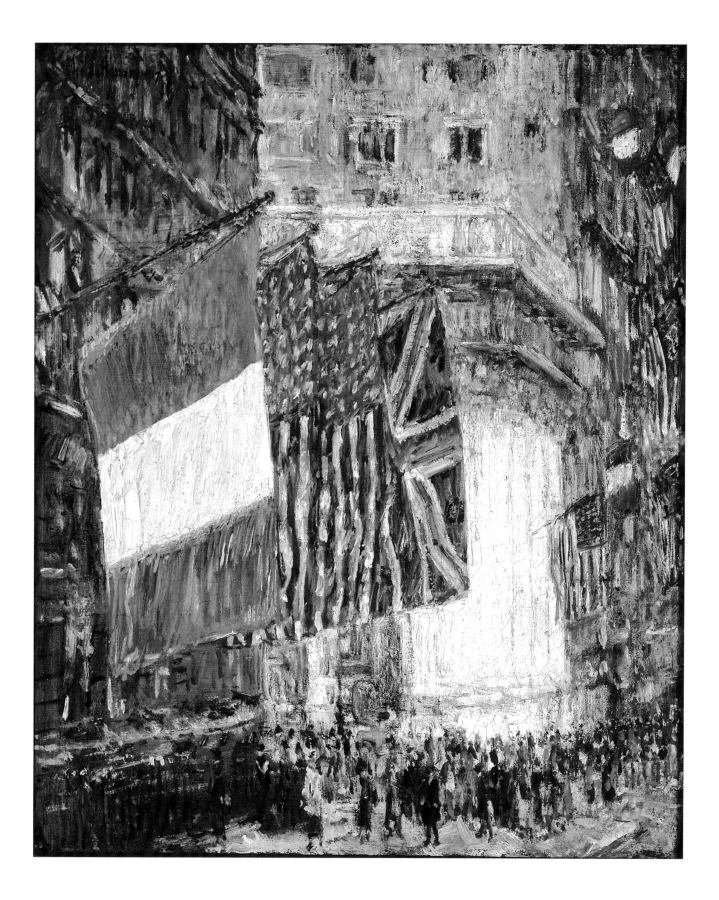

Flying Flags

MENU BY
Paula Deen

Texas Brisket

Southern Fried Chicken

Bacon-Wrapped Grilled Corn on the Cob

Sweet and Spicy Coleslaw

Red Potato Salad

Red Velvet Trifle

Childe Hassam
(American, 1859–1935)
Avenue of the Allies, 1917
Oil on Canvas, 181/8 X 153/16 in.
(46 X 38.6 cm)
Signed and dated upper left, Childe Hassam 1917
Bequest of Elizabeth Millar Bullard 1942.11

Avenue of the Allies is one of a series of about thirty flag paintings created by Childe Hassam during a patriotic display of support for America's allies— Britain and France—in World War I. The view looks up Fifth Avenue, New York's most fashionable street and one representing the country's emerging wealth and power. The flags form a colorful frame, those on the left angled to focus on the Knickerbocker Trust Company, a symbol of that wealth and power, and those on the right reining in the view. Hassam moved in 1886 from his native Boston to Paris where he embraced the loose brushstrokes and flickering color of the French impressionists. Returning from Paris, he settled in New York in 1889 and began painting scenes of urban life. *Avenue of the Allies* has stirred feelings of American pride since its purchase by Trustee Elizabeth Millar Bullard during Gari Melchers' tenure as Telfair's fine arts advisor, and was selected by the US Ambassador to France to hang in the private residence in the late 1990s. Flags, too, are at the core of all Fourth of July celebrations when family and friends come together to show their patriotism and enjoy that most American of all summer staples, fried chicken.

Texas Brisket

 serves 10 to 12

Brisket
1 (5 to 6-pound) brisket, trimmed, leaving
 1/4-inch-thick layer of fat
6 cups Hickory chips, soaked

Rub
6 tablespoons Paula Deen's House
 Seasoning
3 tablespoons Paula Deen's Southern
 Chili Spice
1 1/2 teaspoons brown sugar
1 1/2 teaspoons onion powder
1 teaspoon dried oregano
1 teaspoon cayenne pepper

Rinse the brisket thoroughly under cold water and pat dry with paper towels. In a small bowl, mix together the House Seasoning, Chili Spice, brown sugar, onion powder, oregano, and cayenne. Rub the brisket thoroughly on all sides with the spice mixture.

Follow the directions on your grill or smoker for indirect grilling. Place the soaked chips into the chip box, or make a pouch with tin foil for the chips, then place the pouch directly on the coals. Place the brisket, fat-side up, in a large disposable aluminum pan and place in the center of the grate and cover the grill. Slow-grill the brisket for 6 hours, or until tender and an instant-read thermometer inserted in the center of the meat reads 190 degrees F. Add the coals and wood chips as necessary to maintain a constant temperature. Transfer the brisket to a cutting board to rest for about 10 minutes. Slice the brisket across the grain and serve.

© 2006 by Paula Deen, *Paula Deen Celebrates!*

Southern Fried Chicken

 serves 8

3 eggs
1/3 cup water
1 cup hot red pepper sauce, or as
 needed (Texas Pete brand recommended)
2 cups self-rising flour
1 teaspoon pepper
Paula Deen House Seasoning
1 (1 to 2 1/2-pound) chicken, cut into pieces
Peanut oil, for frying

In a medium-sized bowl, beat the eggs with the water. Add enough hot sauce so the egg mixture turns bright orange. In another bowl, combine the flour and pepper. Season the chicken with the House Seasoning. Dip the seasoned chicken in the egg, and then coat well in the flour mixture.

Heat the oil to 350 degrees F in a deep pot. Do not fill the pot more than 1/2 full with oil. Fry the chicken in the oil until brown and crisp. Do not overcrowd the pot. The dark meat will take 13 to 14 minutes, and the white meat will take 8 to 10 minutes. Drain the chicken pieces on a paper towel before serving.

© 1998 by Paula H. Deen, *The Lady & Sons Savannah Country Cookbook*

Bacon-Wrapped Grilled Corn on the Cob

≈ **serves 8**

8 ears fresh corn
1 pound bacon

Gently pull back the husk, exposing the corn. Do not remove the husk. Remove the corn silk, using a brush to make sure all the silk is removed. Take a strip of bacon and wrap it around the exposed corn. Fold the corn leaves back over, covering the bacon and corn entirely. Tie the leaves with butcher string and repeat the process for each ear of corn. Place the ears of corn on a hot grill and cook for 15 to 20 minutes, turning occasionally, or until the bacon is cooked and the corn is tender.

© 2005 by Paula Deen, *Paula Deen and Friends*

Sweet and Spicy Coleslaw

≈ **serves 8**

6 cups red cabbage, thinly sliced
1/2 cup red apple, matchstick-cut
1/2 cup green apple, matchstick-cut
1/3 cup pumpkin seeds, roasted and salted
2 tablespoons fresh cilantro, chopped
1/3 cup jalapeño pepper jelly
3 tablespoons apple cider vinegar
2 tablespoons olive oil
1 teaspoon salt
Pinch pepper
1/4 teaspoon ground cumin

In a large bowl, combine the cabbage, apples, pumpkin seeds, and cilantro. In a small bowl, combine the jelly, vinegar, oil, salt, pepper, and cumin, stirring until smooth. Pour the dressing over the cabbage mixture and toss gently to coat. Cover the slaw and chill for at least 1 hour before serving. The slaw will keep in the refrigerator for up to 24 hours.

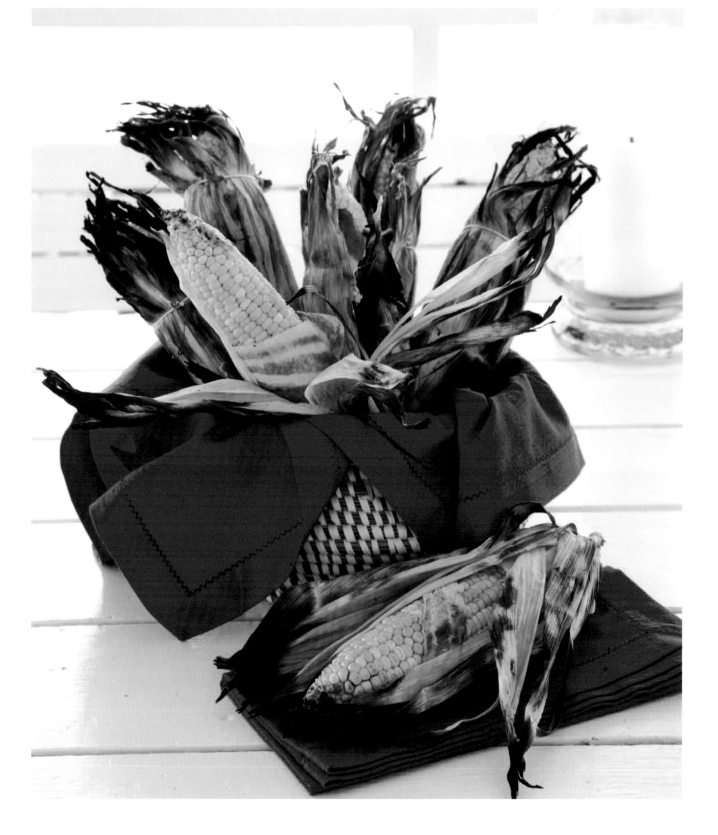

Red Potato Salad

serves 8 to 10

12 cups red potatoes, cubed

1 cup (about 1 medium) green bell
 pepper, cubed

1/2 cup red onion, minced

1/2 cup extra virgin olive oil

1/3 cup red wine vinegar

2 tablespoons Dijon mustard

2 tablespoons mayonnaise

1 1/2 teaspoons salt

1/2 teaspoon ground black pepper

Place the potatoes in a large pot and cover them with water. Over high heat, bring the water to a boil and cook the potatoes for 10 minutes, or until tender. Drain the potatoes well and allow them to cool.

In a large bowl, combine the potatoes, bell pepper, and onion. In a small bowl, whisk together the olive oil, vinegar, Dijon mustard, mayonnaise, salt, and pepper. Pour the dressing over the potato mixture, tossing gently to coat. Cover and refrigerate until ready to serve.

Red Velvet Trifle

serves 6 to 8

Cake

2 eggs
1/2 pound (2 sticks) butter
2 cups sugar
2 tablespoons cocoa
2 ounces red food coloring
2 1/2 cups cake flour
1 teaspoon salt
1 cup buttermilk
1 teaspoon vanilla extract
1/2 teaspoon baking soda
1 tablespoon vinegar

Filling

1 (3-ounce) envelope cheesecake-flavored
 instant pudding
2 cups milk
2 cups freshly whipped cream

Garnish

1/4 cup pecan pieces
Fresh mint leaves

Preheat the oven to 350 degrees F. Spray 3 (8-inch) round cake pans with nonstick cooking spray and set aside.

In a large mixing bowl using a hand mixer, beat the eggs, butter, and sugar until creamy. Add the cocoa and food coloring and mix until well combined.

In a medium mixing bowl, sift together the flour and salt. Alternately add the flour mixture and the buttermilk to the creamed mixture. Blend in the vanilla.

In a small bowl, combine the baking soda and vinegar and add it to the batter. Pour the batter evenly into the prepared pans and bake for 20 to 25 minutes, or until a toothpick inserted in the center comes out clean. Allow the cakes to cool completely.

While the cakes are baking, prepare the instant pudding according to the package directions using 2 cups milk. Allow the pudding to set up in the refrigerator for 10 minutes. Using a spatula, gently fold in the freshly whipped cream.

To assemble the trifle, cut the red velvet cake into 1-inch cubes. Place an even layer of cubed cake in the bottom of a trifle bowl. Top with one-third of the pudding mixture. Repeat the layer process so that the final layer is pudding. Garnish with the pecan pieces and fresh mint leaves and chill until ready to serve.

Independence Day

In May 1776, just prior to the ratification of the Declaration of Independence, a British fleet sailed up the Savannah River searching for provisions. Georgia's Council of Safety ordered the local militia to set some planters' provision barges on fire and let them drift downriver to drive the fleet away. The Inverness, ablaze and loaded with rice, collided with the British craft and set three of the warships on fire—the first fireworks on the river. Like the rest of the country, Savannah did not officially observe Independence Day until 1870 but the celebrating continues today.

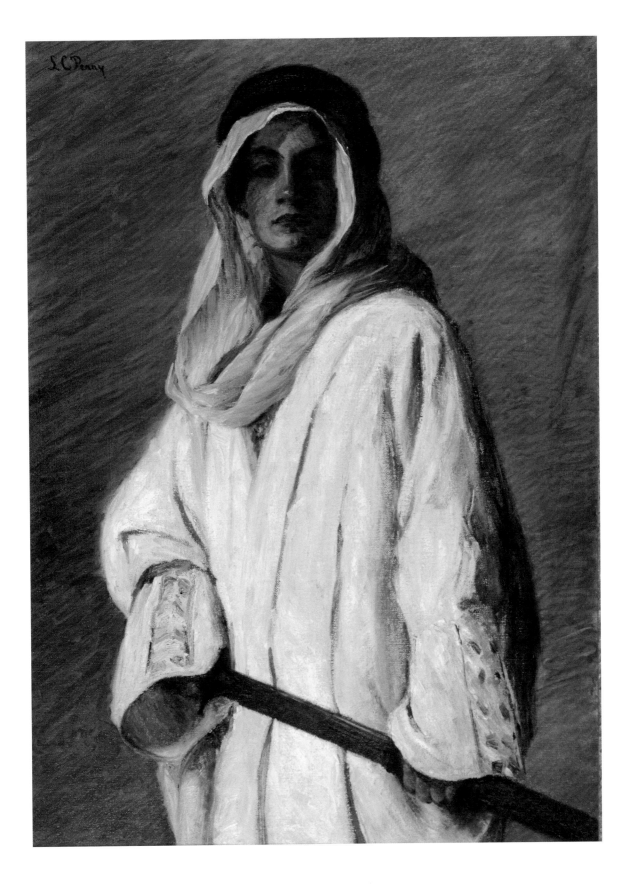

Middle Eastern Feast

MENU BY
Cynthia Creighton-Jones

Hummus bi Tahini

Tabouleh Salad

Tea with Mint

Tagine of Lemon Chicken

Couscous with Dried Fruit and Almonds

Preserved Lemons

Cardamom and Anise Marinated Oranges

Cinnamon Ice Cream

Lilla Cabot Perry
(American, 1848-1933)
Portrait of Kahlil Gibran, c. 1898-99
Oil on canvas, 40 x 29 in. (101.6 x 73.7 cm)
Museum purchase 1999.23

Lilla Cabot Perry's *Portrait of Kahlil Gibran* portrays the young Lebanese artist and poet around the tender age of fifteen. The young Gibran posed for Perry in Boston only a few years after leaving Lebanon in 1895. Using light, airy colors and quick, soft brushstrokes, Perry created an image of Gibran in the impressionist style she acquired from her friend and mentor Claude Monet. As payment for his modeling services, Gibran received his first set of watercolors and the clothing he wore in the portrait. In a practice exploited by other American artists, Perry has posed Gibran wearing Arab garb reminiscent of his homeland, in a manner to emphasize the exotic nature of his origin. Scents of cinnamon, cardamom and star anise seem to fill the air.

Hummus bi Tahini
✥ serves 6 to 8

1 (16-ounce) can chickpeas or garbanzo
 beans, drained, liquid reserved
3 to 5 tablespoons fresh squeezed
 lemon juice, or to taste
1/4 cup liquid from chickpeas
1 1/2 tablespoons tahini (sesame paste)
2 cloves garlic, crushed
2 tablespoons olive oil, plus extra,
 for garnish
Salt
Pepper
Paprika, for garnish
6 to 8 slices pita bread

Wash the chickpeas in a small colander. In a food processor, blend the chickpeas, 3 tablespoons lemon juice, the chickpea liquid, tahini, and garlic until smooth. Add the olive oil and season with salt and pepper to taste. Add the remaining lemon juice, if needed.

Place the hummus in the center of a small serving plate. With a large spoon, spread the hummus out to the edges of the plate in a circular motion. The sides should be a little raised, leaving a dip in the middle. Drizzle with 1 to 2 teaspoons olive oil and sprinkle with paprika to garnish. Serve with hot toasted or grilled pita bread, cut into triangles.

Kahlil Gibran

His inspirational book, *The Prophet*, made Kahlil Gibran the third bestselling poet in the world, behind only Shakespeare and Lao-tzu. but during his lifetime, critics largely overlooked his extensive work as a visual artist. With the help of Boston benefactor and friend, Mary Haskell Minis, Gibran was able to study art in Boston and Paris. Haskell moved to Savannah in 1923, bringing her personal collection of nearly one hundred original Gibran works. Nineteen years after his death, she donated the collection to the Telfair Museum, fulfilling Gibran's wish: "One of my dearest dreams is this—somewhere, a body of work, say fifty or seventy-five pictures will be hung together in a large city, where people would see and perhaps love them."

Tabouleh Salad

serves 6

1/2 cup water
1/4 cup bulghur wheat
1 1/4 pound tomatoes, finely chopped
1 bunch scallions, finely sliced
1 1/2 bunches fresh Italian parsley, chopped
3/4 bunch fresh mint, chopped
2 1/4 teaspoons salt
3/4 teaspoons ground cinnamon
1/2 cup, plus 1 tablespoon fresh squeezed
 lemon juice
1/4 cup, plus 2 tablespoons olive oil

Bring the water to a boil over high heat. Remove the water from the heat and stir in the bulghur wheat. Cover and let stand 20 minutes. In the meantime, chop the tomatoes, scallions, parsley, and mint for the salad.

Using a fork, loosen the bulghur wheat. Stir the vegetables, herbs, salt, cinnamon, lemon juice, and olive oil into the bulghur. Cover and refrigerate for approximately 1 hour before serving. Serve chilled.

Tea with Mint

serves 6

1 1/2 quarts water
Handful fresh mint leaves
6 heaping tablespoons sugar
1 heaping teaspoon green tea

Bring the water to a boil and pour over the mint, sugar, and green tea in a teapot. Let steep for 3 minutes. Pour the first glass off and then pour it back into the teapot to help further steam the sweetness. This tea is traditionally poured with great ceremony from height into special gold-rimmed glasses.

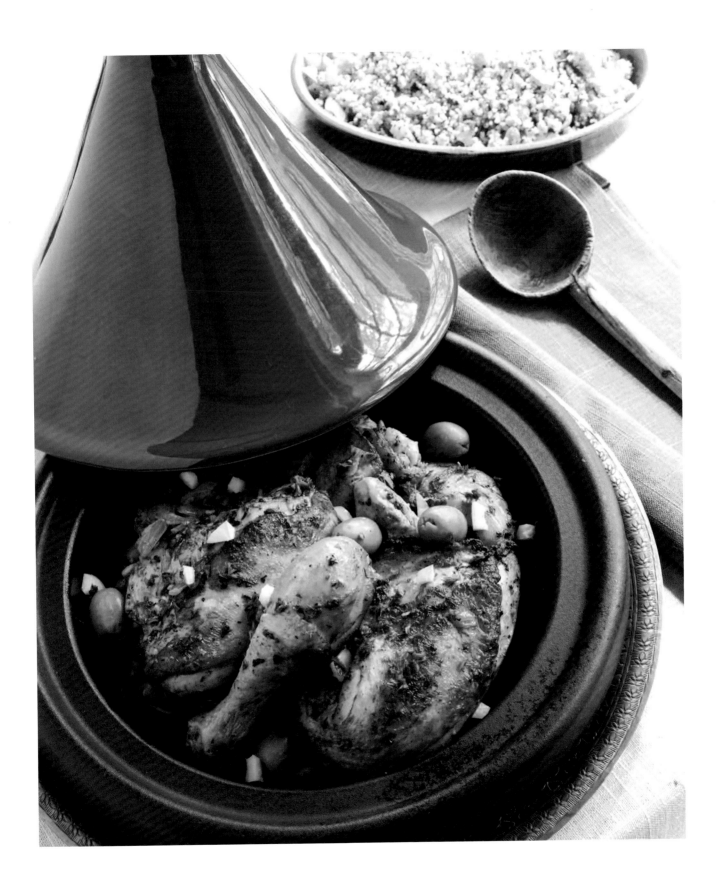

Tagine of Lemon Chicken

∞⌒ **serves 6**

Marinade

4 tablespoons olive oil, plus more for frying
1 tablespoon coarse sea salt
1 teaspoon fresh ground black pepper
1 1/2 teaspoons ground cumin
1 1/2 teaspoons sweet paprika
4 cloves garlic, minced
2 teaspoons fresh ginger, minced
1 handful fresh cilantro leaves, chopped
2 bay leaves
Juice of 1 lemon
1 teaspoon saffron threads

Chicken

2 (4-pound) chickens, backbone removed,
 and cut into 8 pieces
1 medium onion, roughly diced
1/2 cup white wine
1 1/2 cups chicken stock
1 cup pitted green or purple olives (if hard,
 blanch in boiling water for 2 minutes)
2 preserved lemons (available at gourmet
 markets, or see recipe, p.72), flesh
 removed and peel diced, or 1 1/2 lemons,
 thickly sliced

Garnish

1 tablespoon flat-leaf parsley, chopped
1 tablespoon fresh cilantro, chopped

In a large bowl, add the oil, salt, pepper, cumin, paprika, garlic, ginger, cilantro, bay leaves, lemon juice, and saffron. Mix into a paste. Add the chicken, rubbing the marinade all over the pieces. Cover and refrigerate for 2 hours or overnight.

Preheat the oven to 350 degrees F. Remove the chicken from the marinade and reserve the marinade. Place the oil in a large ovenproof skillet or Dutch oven over medium-high heat. Add the chicken in batches (don't crowd the pan) and brown on all sides. Remove the chicken and the excess fat from the skillet. Add the onion and cook for 3 minutes, or until it begins to brown. Return the chicken to the pan. Add the reserved marinade, white wine, and chicken stock and bring to a boil. Cover the skillet, place it in the oven, and bake for 30 minutes.

Add the olives and lemons, basting and turning the chicken. Leave the skillet uncovered and bake for an additional 10 minutes. Remove the chicken from the oven. Remove the bay leaf and discard. Taste the juices and adjust the seasoning as desired.

To serve, place the chicken on a warm platter and spoon the juices with the preserved lemon, olives, and onions over chicken. Scatter the chopped parsley and cilantro over the top. Serve with Couscous with Dried Fruit and Almonds (see recipe, p.72).

Note: This dish is traditionally cooked in a Tagine (as pictured). The shape of the Tagine causes the steam generated during the cooking process to drip back into the base of the Tagine, enhancing the flavor of the dish.

Couscous with Dried Fruit and Almonds

❧ serves 6

2 cups dried couscous
1/4 cup dates, finely chopped
1/4 cup golden raisins
1/4 cup dried apricots, cubed
1/4 cup almond slivers, toasted
1 teaspoon salt
4 cups chicken stock

In a medium pot, mix the couscous with the dates, raisins, apricots, almonds, and salt. In a smaller pot, bring the chicken stock to a boil. Pour the stock over the couscous mixture. Cover and let rest for 10 minutes. When the couscous is done, fluff it with a fork, transfer to a platter, and serve with the Tagine of Lemon Chicken (see recipe, p. 71).

Preserved Lemons

❧ yields 1 jar

Enough lemons to fill a sealable jar
 of your choosing
Coarse sea salt
Enough vegetable oil to cover the lemons

Wash the lemons under cold running water, then pat them dry. Cut a small slice off the bottom of each lemon so that it can stand upright. With the lemon standing upright, slice the lemon horizontally, two-thirds of the way the way through. Slice the lemon again two-thirds in half vertically (perpendicular to the first cut), again not slicing all the way through. Squeeze the cuts open and fill each lemon with about 1 tablespoon of salt. Pack the lemons tightly into the jar and fill the jar completely with the vegetable oil. Seal the jar and refrigerate for at least 1 month, or up to 6 months.

When ready to use these lemons, scrape away the seeds and the remnants of the flesh, and use only the skins. Before using, blanch them in boiling water for up to 1 minute to remove any bitterness.

Note: You can use fresh lemons in place of preserved lemons by following the cutting procedure above. Scrape away the seeds and the remnants of the flesh of the fresh lemons, and use only the skins. Before using, blanch them in boiling water for up to 1 minute to remove any bitterness.

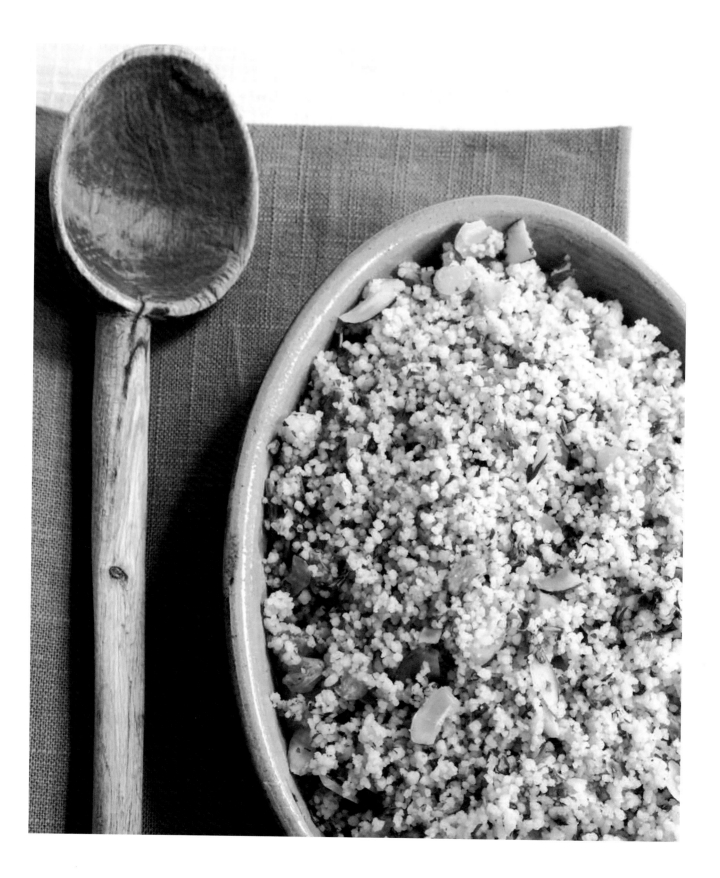

Cardamom and Anise Marinated Oranges

 serves 8 to 10

4 cups sugar
3 cups water
4 cardamom seeds
6 whole cloves
3 star anise
1 cinnamon stick
1/4 vanilla bean
1 lemon, quartered
1/2 cup honey
1/2 cup Grand Marnier
4 drops red food coloring
6 whole oranges, peeled

Cook the sugar and water together in a saucepot over high heat to form a simple syrup. Add the cardamom seeds, cloves, star anise, cinnamon, vanilla, and lemon and simmer for 10 minutes. Remove the mixture from the heat and cool. Add the honey, liquor, and food coloring and stir. Add the oranges. Place parchment paper over the pot top and store in the refrigerator for up to 3 days before using, allowing the oranges to stew in the marinade.

To serve, remove the oranges from the marinade and slice into rings. Lay the orange slices (about 4 per serving, or more if you wish) in a tight circle on a plate. Pour a little of the marinade over the oranges and place a scoop of Cinnamon Ice Cream in the center of the orange slices.

Cinnamon Ice Cream

yields 1 quart

3 cups milk
1 1/4 cups sugar, divided
1 cup heavy cream
1/2 vanilla bean, split lengthwise,
 seeds scraped
1 large cinnamon stick
12 large egg yolks
1/4 teaspoon ground cinnamon,
 or to taste
Pinch salt

Bring the milk, 1 cup sugar, heavy cream, vanilla pod and pulp, and the cinnamon stick to a simmer in a heavy-bottomed saucepan over medium heat.

Meanwhile, whisk together the egg yolks and the remaining sugar. Remove the milk mixture from the heat and add a little to the egg yolk mixture to warm it, whisking constantly to keep the egg yolks from curdling. Pour the egg yolk mixture into the hot milk mixture, whisking the milk constantly as you pour.

Return the custard to the heat and cook it over low heat, stirring constantly with a wooden spoon, until it thickens enough to coat the back of the spoon. Remove the custard from the heat and pour it into a bowl. Let it cool completely.

Strain the custard through a fine sieve, then stir in the cinnamon and salt. Chill for at least 4 hours. Freeze in an ice cream maker according to the manufacturer's instructions. Make the ice cream a day ahead so it will freeze properly.

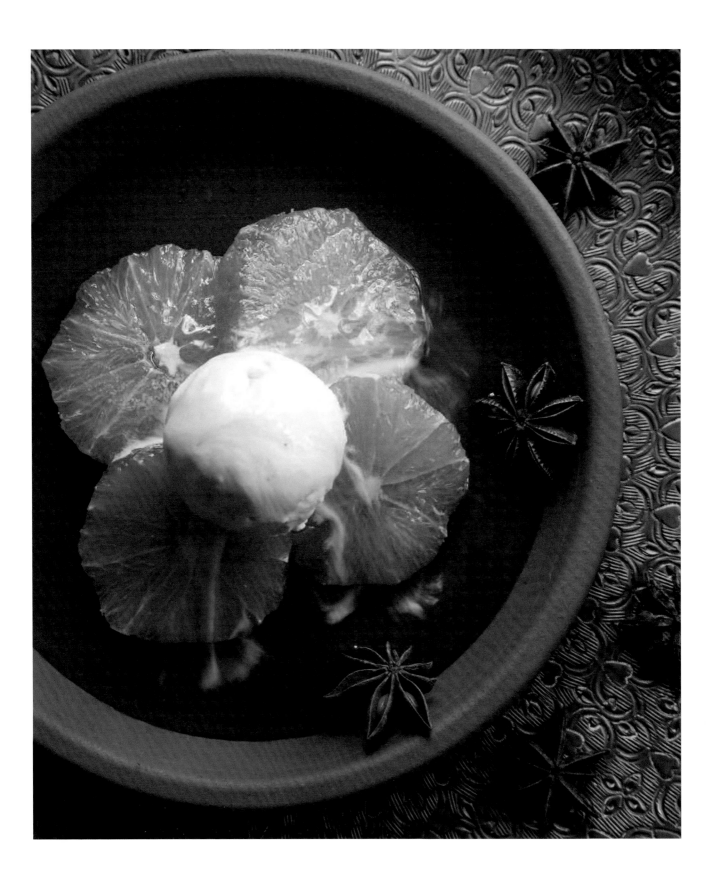

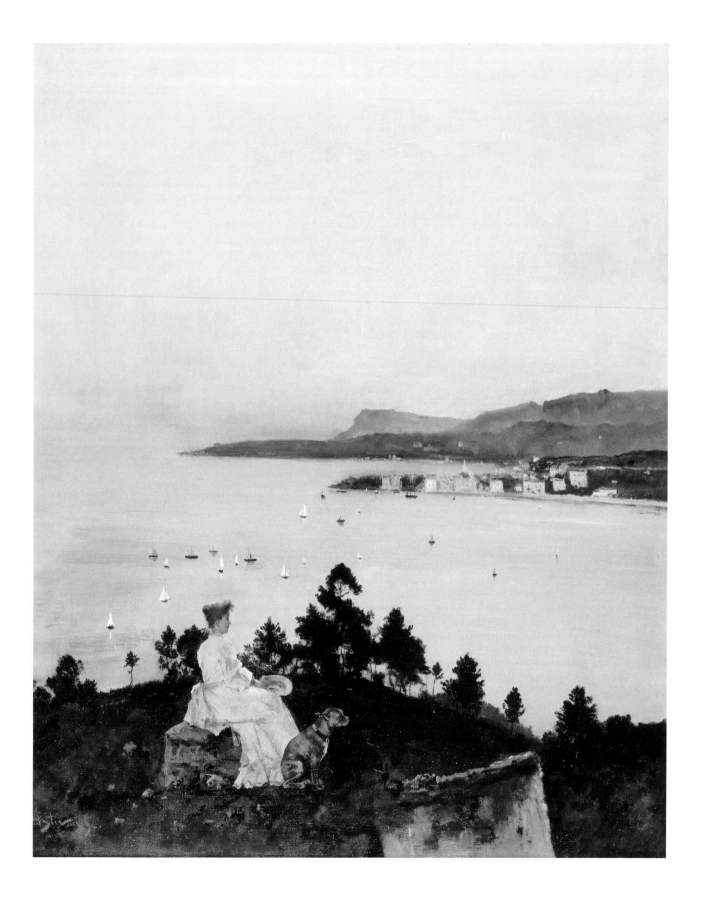

Lazy Days

MENU BY

Trish McLeod
and John Nichols

Lemongrass Grilled Shrimp – *T. M.*

Black Bean, Corn, and Rice Salad
with Goat Cheese Dressing – *J.N.*

Bourbon-Marinated Pork Tenderloin
with Mustard Cream Sauce – *J.N.*

Blanched Green Beans with Tomato Basil Dip – *J.N.*

Sweet Potato Biscuits – *J.N.*

Quinoa Salad – *T. M.*

Watermelon Sorbet – *T. M.*

Alfred Stevens
(Belgian, 1823-1906)
Jour de régates, Menton
(Regatta Day at Menton), 1894
Oil on canvas, 32 x 26 in. (81.9 x 66 cm)
Museum purchase 1916.3

Belgian artist Alfred Stevens moved to Paris in the 1850s, and like his contemporary Gustave Courbet, established his early reputation with Social Realist works portraying beggars and other downtrodden characters. Stevens turned in his mature career to portrayals of society women in highly fashionable dress, often in elegantly appointed salons. *Regatta Day at Menton*, which was purchased for the Telfair by Gari Melchers in 1916, does feature an elegantly dressed woman, but she is shown outside of the confines of her home. Rather, she is seated atop a hill, enjoying an expansive view of a regatta in the bay below. Her pink sash cascades merrily behind her and her dog sits companionably at her feet, attentively observing the vista before him. The woman has removed her hat, to better feel the sea breeze and the sun on her face, or perhaps to prepare to enjoy a summer meal of seafood and sorbet.

Lemongrass Grilled Shrimp

 serves 6

Marinade (Yields 1 cup)

2 tablespoons lemon grass, minced

4 tablespoons fresh squeezed lemon juice

1 teaspoon lemon rind

1/2 cup olive oil or canola oil

2 cloves garlic, peeled and finely minced

1 teaspoon salt

1 teaspoon sugar

2 teaspoons grainy mustard or Dijon mustard

1 1/2 pounds shrimp, peeled and deveined,
with tails on or off

Peel off 1 or 2 outer leaves of the lemongrass stalk. Using only the white part of the stalk, mince or grate through a food processor (you will only use about 1 1/2 inches of the bottom of the lemongrass stalk). Place the grated lemongrass into a large bowl, along with the lemon juice, rind, oil, garlic, salt, sugar, and mustard. Mix well and refrigerate, covered, for up to 1 week. The marinade can also be used as a salad dressing.

Marinate the shrimp in the lemongrass mixture for 30 minutes to 1 hour. Slide the shrimp onto skewers that have been soaked in water, or place them in a grill basket to cook. Cook the shrimp for 1 to 2 minutes on each side, or until they are pink and just cooked.

Black Bean, Corn, and Rice Salad with Goat Cheese Dressing

 serves 8 to 10

Dressing

1/2 cup extra virgin olive oil

1 cup crumbled mild goat cheese

1/4 cup fine red wine vinegar

1 tablespoon fresh oregano, chopped

1 tablespoon ground cumin

Salt and pepper to taste

Salad

2 1/2 cups converted rice

10 ounces frozen yellow corn, thawed, drained

3/4 cup sweet red pepper, chopped

3/4 cup sweet orange pepper, chopped

1 cup green bell pepper, chopped

1/2 cup red onion, chopped

2 green onions, chopped

1 (15 1/2-ounce) can black beans, drained
and rinsed

To make the dressing, combine the olive oil, goat cheese, vinegar, oregano, and cumin in a bowl and whisk until well blended. Season with salt and pepper and set aside.

To make the salad, cook the rice according to package directions. Transfer the rice to a bowl and fluff with a fork. Pour the goat cheese dressing over the hot rice and let cool, tossing occasionally. Mix in the corn, peppers, red and green onions, and black beans. Adjust the seasoning to taste. Cover the salad and refrigerate. Remove from the refrigerator 2 hours before serving and allow the salad to come to room temperature before serving.

Bourbon-Marinated Pork Tenderloin

⤸ **serves 8**

1/2 cup soy sauce
1/2 cup bourbon (or apple juice)
4 tablespoons dark brown sugar
3 pounds pork tenderloin

Combine the soy sauce, bourbon, and sugar in a sealable plastic bag. Prick the tenderloins several times with a fork, place them in the plastic bag, seal and refrigerate for at least 8 hours or overnight.

Remove the pork from the marinade and discard the marinade. Grill the tenderloins over medium heat with the grill lid closed for 12 minutes on each side. Serve hot, or at room temperature with Mustard Cream Sauce, or Sweet Potato Biscuits.

Mustard Cream Sauce

⤸ **yields 3/4 cup**

1 1/2 teaspoons white vinegar
1 tablespoon dry mustard
1/3 cup sour cream
1/3 cup mayonnaise
1 tablespoon yellow onion, minced

In a medium bowl, blend the vinegar and dry mustard until smooth. Add the sour cream, mayonnaise, and onion and mix well until incorporated. Cover and chill until ready to serve. Serve with Bourbon-Marinated Pork Tenderloin.

Blanched Green Beans with Tomato Basil Dip

⤸ **serves 8**

3/4 pound fresh green beans, or haricot verts

Dip
1/4 cup mayonnaise
1/8 cup sour cream
1/8 cup fresh basil, chopped
1/4 tablespoon tomato paste
1/4 tablespoon lemon rind, grated

Place the green beans in salted boiling water for about 1 minute. Plunge the beans into an ice water bath to chill.

In a separate bowl, whisk together the mayonnaise, sour cream, basil, tomato paste, and lemon rind. Cover the dip and chill. Serve the beans at room temperature with the cold tomato basil dip.

Sweet Potato Biscuits
yields 2 dozen

1 (1/4-ounce) envelope active dry yeast
1/4 cup warm water
1/2 cup (1 stick) butter, softened
1 cup sweet potatoes, mashed
1/2 cup sugar
2 teaspoons cinnamon
1 teaspoon salt
2 1/2 cups all-purpose flour
1 teaspoon baking powder
Melted butter

Quick and Easy Recipe Option
3 cups Bisquik mix
2 cups Bruce's brand Sweet Potato
 Pancake Mix
2 teaspoons cinnamon
Whole milk, as needed

Combine the yeast and warm water in a glass cup and let stand for 5 minutes. Stir together the butter and mashed sweet potatoes. Stir the sugar, cinnamon, salt, and yeast mixture into the mashed potatoes.

In a separate bowl, combine the flour and baking powder. Gradually stir the flour mixture into the potato mixture and blend well. Knead the dough lightly until it holds together.

Shape the dough into a ball and place it in a buttered bowl twice the size of the dough ball. Brush the top with melted butter. Cover the dough and allow it to rise in a warm place for 2 to 3 hours, or until it has doubled in size.

Once the dough has risen, punch it down in the bowl and turn it out onto a lightly floured surface. Roll the dough to a 1/2-inch thickness and cut with a 2-inch round biscuit cutter. Place the biscuits on greased baking sheets. Cover and let the dough rise in a warm place that is free from drafts for 2 more hours.

Bake at 400 degrees F for 12 minutes, or until golden brown. Brush the biscuits with melted butter and serve.

To make the quick and easy option, combine the Bisquick, pancake mix, and cinnamon in a large bowl. Gradually add the milk until the dough forms and sticks slightly to the bowl. Turn out the dough onto a Bisquick-covered surface and roll out to a 1/2-inch thickness. Cut the dough with a 2-inch biscuit cutter and place the biscuits on a parchment-lined baking sheet, edges touching. Bake at 400 degrees F for about 12 minutes or until golden brown. Brush the tops with melted butter.

Quinoa Salad

 serves 6 to 8

12 cups water
1 1/2 cups quinoa
1 English cucumber, peeled and cut into
 1/4-inch cubes
1 large shallot or small red onion, cut
 into 1/4-inch cubes
20 sweet grape tomatoes, halved
1/4 cup Italian parsley, chopped
1/2 cup plus 2 tablespoons crumbled feta cheese
1 whole avocado, cubed
Salt
Pepper
1 head baby lettuce, or arugula

Vinaigrette
1/4 cup red wine vinegar
Juice of 1 lemon
1/2 cup olive oil

Bring the water to a boil. Add the quinoa, stir, and return to a boil. Cook over medium heat, uncovered, for 11 to 12 minutes. Strain in a colander and rinse well. Pat the quinoa with a paper towel to absorb excess moisture, then place the prepared quinoa in a large bowl. Add the cucumber, shallot, tomatoes, parsley, 1/2 cup feta, avocados, salt, and pepper.

To make the vinaigrette, whisk together the red wine vinegar, lemon juice, and olive oil. Pour the vinaigrette over the quinoa and toss gently to combine.

Serve the salad over a bed of baby lettuce or arugula and garnish with additional feta. The salad can be made up to one day ahead and stored, covered, in the refrigerator until ready to serve.

Watermelon Sorbet

 serves 8

Simple Syrup
1 cup water
1 cup sugar

Sorbet
8 cups watermelon, seeded and cubed
1 cup simple syrup
2 tablespoons fresh squeezed lemon juice

Make a simple syrup by combining 1 cup water and 1 cup sugar in a saucepan over high heat. Bring the syrup to a boil and cook until the sugar is dissolved completely. Set aside to cool.

Puree the watermelon in a food processor until smooth. Place 4 cups of the puree in a large bowl and add 1 cup simple syrup and lemon juice. Stir well. Freeze the mixture in an ice cream maker according to the manufacturer's instructions. The sorbet will keep in the freezer for up to 3 weeks.

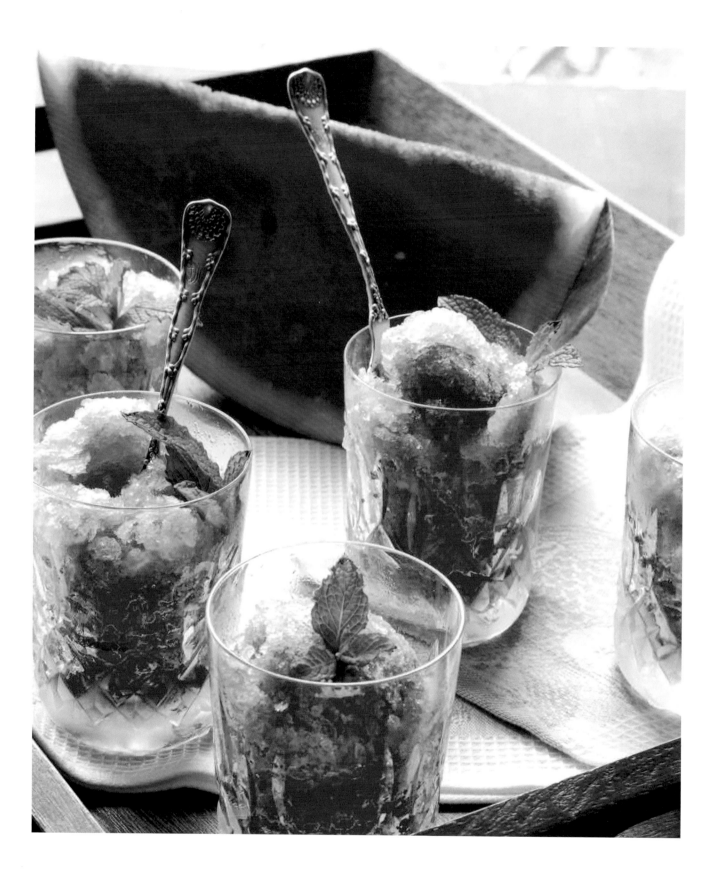

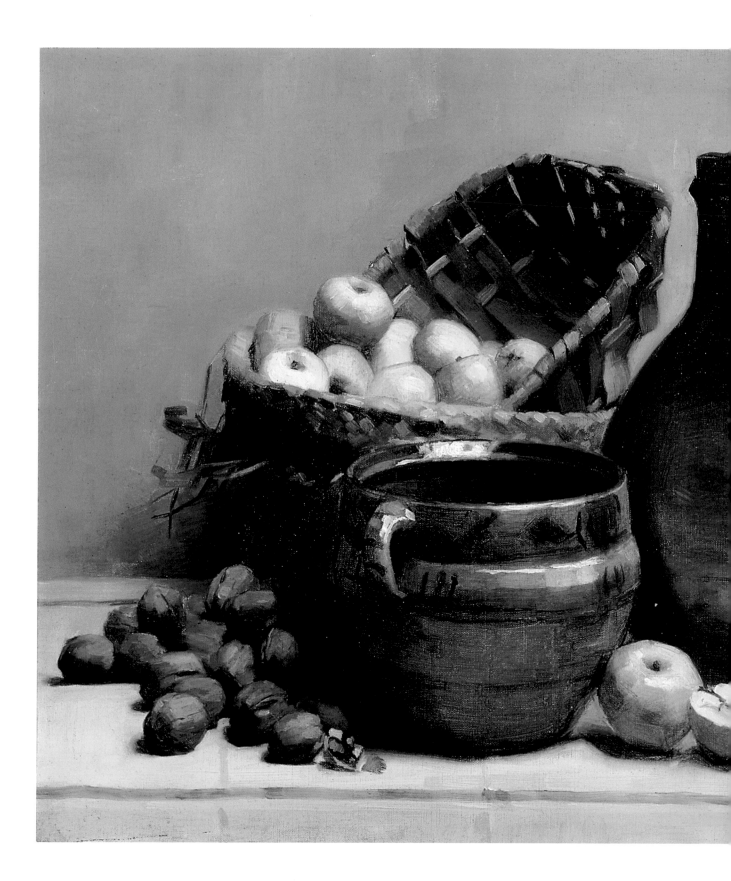

Fall

Celebrate the Harvest
Menu by The Committee

The Hunting Party
Menu by Nick Mueller

Down by the Riverside
Menu by Susan Mason

Straight From the Hearth
Menu by Cynthia Creighton-Jones

Beulah Strong
(American, 1866-1951)
Still Life with Apples and Nuts, before 1890
Oil on canvas, 19 13/16 x 24 1/8 in.
(50.3 x 61.3 cm)
Museum purchase 1890.1

When she painted this still life, Beulah Strong was in her early twenties and studying in Paris under Jules Lefebvre and Gustave Boulanger. Carl Brandt, the Telfair's first director, selected *Still Life with Apples and Nuts* as one of thirty-seven works he purchased for the museum in 1890 and the only piece by a woman artist that he ever purchased for the Telfair.

In this simple but harmonious composition, Strong contrasts the fruits of the autumn harvest—bright yellow apples and rough-textured walnuts—with a glazed earthenware bowl and reflective green jug. Adding interest is a mirror image of a landscape in the glass of the jug, probably a view through the window of her Paris studio.

Harvested fruits and nuts are the harbingers of shorter days and cooler temperatures. Hunting season opens and oysters are once again in season. Okra and fall tomatoes abound, and the warmth of a fire and satisfying comfort foods beckon.

Celebrate the Harvest

MENU BY
The Committee

Augusta Denk Oelschig
(American, 1918-2000)
Old City Market, c. early 1950s
Oil on panel, 36 x 48 in.
Purchased through funds provided by the
Telfair Academy Guild 1999.22

Savannah native Augusta Oelschig studied under renowned Georgia artist Lamar Dodd at the University of Georgia, and later under noted modernist Henry Lee McFee in Savannah. Although her subject matter ranged from still lifes to scathing political commentary, she is best known for her American scene paintings. *Old City Market* depicts the City Market building that stood in Savannah's Ellis Square from 1872 until its demolition in 1953. Dismay over the loss of this landmark spurred the creation of the Historic Savannah Foundation, which still works today to preserve threatened historic structures. Oelschig depicts the market teeming with activity: shoppers of all ages and walks of life come and go, pedestrians and animals make their way through the crowd, and busy vendors ready their greens, tomatoes, melons, and other produce for sale.

Endive with Goat Cheese Topped with
Fried Okra and Tomato

Petite Crabcakes in Phyllo Cups with
Red Pepper Remoulade Sauce

Peppered Sea Scallops with Pan-Fried
Grit Cakes and Tomato Gravy

Wedge Salad with Butter Beans,
Pickled Okra, Bacon, and Blue Cheese

Rack of Pork Loin with Cornbread
with Cornbread Sausage Stuffing

Delightful Biscuits

(suggested accompaniment)
Assorted tartlets from your favorite bakery

Endive with Goat Cheese Topped with Fried Okra and Tomato

❧ **yields 50**

14 ounces goat cheese
1 (3-ounce) package cream cheese
1 tablespoon mayonnaise
8 heads Belgian endive
8 grape or cherry tomatoes, thinly sliced
1/2 cup cornmeal
1 tablespoon flour
8 medium okra pods, sliced
2 cups vegetable oil, for frying
Fresh parsley, for garnish

Mix the goat cheese, cream cheese, and mayonnaise together in a bowl until smooth. Set aside.

Clean and separate the leaves of the endive and place the leaves on trays, spaced evenly apart. Fill a pastry tube or bag with the cheese mixture and pipe about 1 1/2 teaspoons of the mixture onto each endive leaf.

Slice the tomatoes thinly and set aside to drain on a paper towel.

In a shallow bowl, combine the cornmeal and flour. Slice the okra pods into rounds and coat the okra in the meal mixture. Heat the oil in a skillet or Dutch oven and fry the okra. Set the fried okra aside on a paper towel to drain before assembling.

To serve, place a tomato slice, a fried okra piece, and a parsley leaf on top of the cheese mixture on each endive leaf.

Petite Crabcakes in Phyllo Cups
with Red Pepper Remoulade Sauce

serves 8

Crabcakes
1 egg, beaten
1/4 cup mayonnaise
1 tablespoon red pepper, diced
1 tablespoon yellow pepper, diced
1 tablespoon sweet onion, diced
1/2 teaspoon dry mustard
1 tablespoon Old Bay Seasoning
8 ounces lump blue crab meat
16 mini phyllo shells (available at
 gourmet markets)

Red Pepper Remoulade
1/2 cup mayonnaise
1/2 cup red pepper, diced
1/2 cup sweet onion, diced

Preheat the oven to 375 degrees F.

To make the crabcakes, blend the egg and mayonnaise in a medium bowl. Mix in the peppers, onion, mustard, and Old Bay Seasoning. Gently fold in the lump crab meat until the peppers and onions are well distributed. Fill each phyllo cup with 1 tablespoon of the crab mixture. Place the filled phyllo cups on a baking sheet and bake for 15 minutes.

While the crabcakes are baking, make the remoulade. Blend the mayonnaise with the peppers and onion in a food processor until the mixture is smooth. Serve the crabcakes with a dollop of the remoulade sauce.

Peppered Sea Scallops with Pan-Fried Grit Cakes and Tomato Gravy

serves 8

Peppered Sea Scallops

16 large sea scallops
1 tablespoon fresh ground pepper,
 coarse grind
2 teaspoons sea salt
4 tablespoons olive oil

Pan-Fried Grit Cakes

6 cups water
2 teaspoons salt
2 cups stone ground grits
1 cup heavy cream
4 tablespoons (1/2 stick) butter
1 cup cornmeal
1/4 cup olive oil

Tomato Gravy

4 tablespoons (1/2 stick) butter
3 tablespoons all-purpose flour
2 cups milk
1/2 cup tomato juice or V8 juice
1 cup diced tomato, fresh or canned
2 teaspoons salt
3 tablespoons basil, chiffonade

Season each scallop with black pepper and salt on each side. Heat the olive oil in a heavy frying pan over high heat and sear the scallops until they are golden brown, checking for doneness after 1 minute. Turn the scallops over and cook on the other side for 4 to 5 minutes, or until golden. Remove from the heat and allow the scallops to rest.

To make the grit cakes, bring the water and salt to a boil. Whisk the grits into the boiling water and stir constantly until well incorporated. Reduce the heat to low and cook for 30 minutes, stirring frequently. Add the cream and butter and cook another 15 minutes. The grits should be soft and creamy.

Pour the grits into a 9 x 13-inch pan. Cool the grits to room temperature and then refrigerate (this can be done a day ahead). When the grits are set, cut into 2-inch circles (the cakes should be 1 1/4 inches thick) and dust each grit cake on both sides with the cornmeal.

Pan-fry the grit cakes in olive oil over medium-high heat until they are golden brown. Drain the cakes on a paper towel and keep warm in a warming drawer or warm oven until ready to assemble.

To make the gravy, heat 3 tablespoons butter in a medium saucepan over medium-high heat. Add the flour and reduce the heat to low. Cook for 3 to 4 minutes, then add half of the milk and stir well until the mixture becomes thick. Add the rest of the milk and the tomato juice and stir until the mixture thickens. Add the diced tomatoes to the gravy and cook over low heat for 10 minutes. Reduce the heat to a very low simmer and cook for another 15 minutes. Add the remaining tablespoon of butter and set aside.

To assemble the dish, place a grit cake on each plate. Place 2 scallops on top of each grit cake and drizzle 3 tablespoons of tomato gravy over the top. Garnish each cake stack with the basil chiffonade and serve.

Wedge Salad with Butter Beans, Pickled Okra, Bacon, and Blue Cheese

✑ serves 8

Basil Buttermilk Dressing

1/2 cup fresh basil leaves

2 tablespoons lemon juice

1 tablespoon Dijon mustard

1 tablespoon olive oil

1 teaspoon granulated garlic

2 teaspoons salt

1 teaspoon pepper

1 cup mayonnaise

1/2 cup buttermilk

1/2 cup sour cream

Salad

2 cups water

2 slices uncooked bacon, chopped

1 tablespoon salt

1 (12-ounce) bag frozen baby lima beans,
 or butter beans

10 whole pickled okra pods, cut
 into 1/2-inch slices

4 slices cooked Applewood bacon, crumbled

16 grape tomatoes, halved

1 large head Iceberg lettuce

1 medium Vidalia onion, halved and sliced

4 ounces blue cheese crumbles

To prepare the dressing, place the basil, lemon juice, mustard, olive oil, garlic, salt, and pepper into the work bowl of a food processor and puree. Add the mayonnaise, buttermilk, and sour cream to the mixture and blend until smooth. Place the dressing in a jar and chill in the refrigerator for a least 1 hour, or up to 24 hours.

Bring the water to a boil, adding the uncooked bacon, salt, and lima beans. Once the beans come to a boil, reduce the heat to low and simmer for 25 minutes. Drain the beans and discard the bacon pieces. In a bowl, combine the lima beans, pickled okra slices, crumbled Applewood bacon, and tomatoes. Mix in 3 tablespoons of the basil buttermilk dressing to lightly dress the mixture.

Cut the head of Iceberg lettuce into 8 large wedges and place each wedge on a salad plate. Top each lettuce wedge with the butter bean mixture, onion slices, and the blue cheese crumbles. Drizzle the basil buttermilk dressing over each salad wedge and serve.

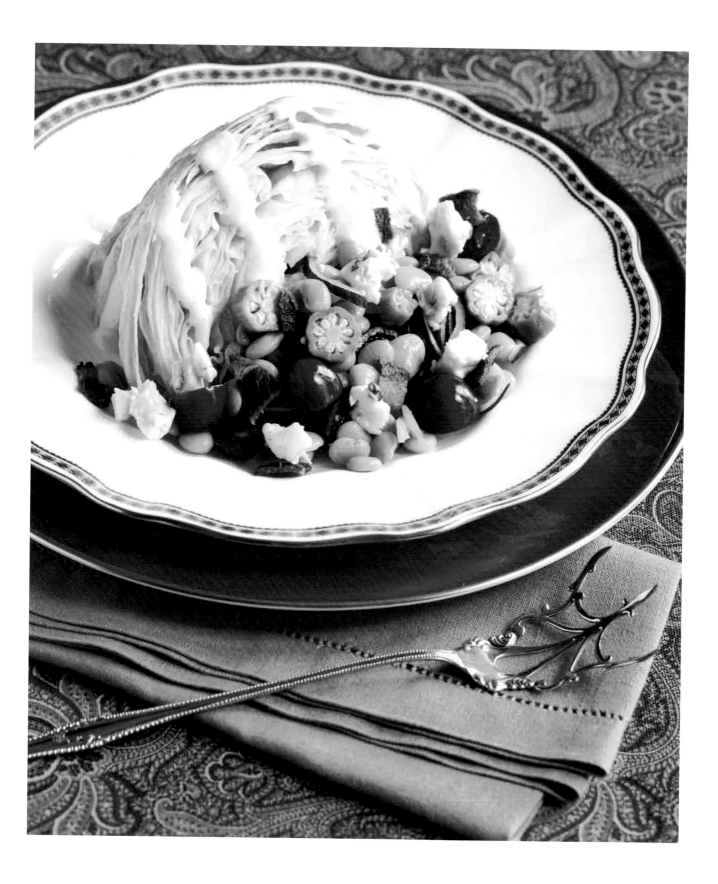

Rack of Pork Loin with Cornbread Sausage Stuffing

serves 8

Pork Loin
1 (8 to 10 bone) pork loin, Frenched
 and butterflied
10 slices Applewood bacon
1 quart (4 cups) chicken stock

Cornbread
1 egg, slightly beaten
1 cup buttermilk
1/4 cup vegetable oil
1 1/4 cups self-rising cornmeal mix

Cornbread Sausage Stuffing
1/4 cup onion
1/4 cup celery
1/2 cup chicken stock, plus more
 as needed
1/2 pound bulk sausage
1/2 cup (1 stick) butter, melted
1/2 teaspoon salt
1/2 teaspoon pepper
1/4 teaspoon dried sage
1 egg, slightly beaten
1 recipe prepared cornbread
5 saltines, crushed

8 ounces green pepper jelly

Ask your butcher to prepare the pork loin by Frenching the bones and butterflying the loin for stuffing. You can also provide the cor bread stuffing for him to put inside the butterflied pork roast. The rack will be tied together with string and then wrapped with Applewood bacon to seal the pork loin.

To prepare the pork loin, preheat the oven to 425 degrees F. Place the loin in a large roasting pan and pour the chicken stock in the bottom of the pan. Roast for 20 minutes, then reduce the heat to 325 degrees F. Cook for 1 1/2 hours at 325 degrees F, or until the internal temperature of the meat is 150 degrees F. Remove the roast from the oven and let it rest, tented with foil, for 15 to 20 minutes. Slice the pork loin along the bone and remove the string.

To prepare the cornbread for the stuffing, heat the oven to 450 degrees F. Coat an ovenproof skillet with nonstick spray. Beat the egg in a medium bowl. Stir in the milk, oil, and cornmeal mix until smooth—the batter should be creamy. If it is too thick, add more milk. Pour the batter into the prepared skillet and bake for 20 minutes, or until golden brown. Remove the cornbread from the oven and set aside.

For the stuffing, puree the onion, celery, and 1/2 cup chicken stock in a blender. Cook the sausage in a skillet over medium heat until it is brown and crumbled. Drain the meat well and mix with the pureed ingredients and the butter, salt, pepper, sage, egg, cornbread, and saltines until the mixture has the consistency of oatmeal. Use the additional chicken stock to bring the stuffing to the desired consistency.

Serve each chop with the cornbread sausage stuffing and a dollop of pepper jelly on the side.

Delightful Biscuits

yields 2 dozen miniature, or 1 dozen full-size ◌

1 cup (2 sticks) butter, room temperature
1 cup sour cream
2 cups self-rising flour

Preheat the oven to 450 degrees F. Combine the butter and sour cream and mix well. Add the flour and mix well. Spoon the batter into ungreased miniature muffin tins and bake for 15 minutes. If desired, use full size muffin pans and bake for 20 to 25 minutes.

Savannah City Market

Beginning in the early 1700s, the City Market in Ellis Square served as Savannah's commercial center. Farmers and fishermen hawked scuppernongs, pigeon peas, and fresh seafood of every description. Horses pulled in wagons brimming with rabbit tobacco, watermelon, and okra.

Fire destroyed the first two market buildings in 1788 and 1820. Wreckers tore down the third, after its use as a dressing station during the Civil War. The 1872 Market building, which Savannahians remember so nostalgically, was an ornate brick structure with Romanesque arches, large circular windows, and a soaring 50-foot roofline. This building survived a hurricane, but it could not weather the age of air-conditioned supermarkets. Planners considered it an obstructive relic, and despite heated debate, the grand old Market building met the wrecking ball in 1954. With a final "hurrah!"—and in true Savannah style—citizens said their last good-byes on October 31, 1953, at an elaborate party known as the Market Ball.

The market's demolition fired the determination of historic-minded Savannahians, who vowed to protect and preserve other historic structures in the city. Led by seven local women, the group that failed to save the old Market building went on to form the Historic Savannah Foundation. This highly successful organization helped remove the unsightly parking garage erected on the market site in the 1950s, so that today horse-drawn carriages once again circle beautiful Ellis Square, the heart of the thriving City Market district.

The Hunting Party

MENU BY
Nick Mueller

Guido von Maffei
(German, 1838- ?)
The Boar Hunt, c. 1882-83
Oil on canvas, 42 3/8 x 60 1/4 in.
Museum purchase 1883.2

Carl Brandt, the museum's first director, purchased this realistically rendered hunting scene in Munich on his first European quest for art for the Telfair in 1883. Von Maffei, a passionate sportsman who owned large hunting preserves in Bohemia, painted many lifelike depictions of animals. In this painting he vividly captures the pose and posture of the braying dachshund and cornered boar. The dramatic diagonal formed by the felled tree at the center of the composition heightens the drama of the scene.

A fall day spent in the woods and fields inspires a hearty menu of wild boar and quail. Rustic yet elegant side dishes, such as buttermilk grits and sweet potato hoe cakes, satisfy the appetite as hunters retell stories of the chase. Celebrate the season's bounty, and raise a final toast to all those long days afield.

Oven-Roasted Tomato Gazpacho
with Herb-Scented Georgia White Shrimp

Mixed Greens Salad with Roasted Pears,
Toasted Pecans, and White Truffle Vinaigrette

Hickory-Smoked Boar
over Sweet Potato Hoe Cakes

Pan-Fried Quail with Stone Ground
Buttermilk Grits and Red-Eye Gravy

Selection of Cheese with Savannah Bee Company
Honeycomb, Drunken Apples and Crackers

Lemon Cornmeal Cake
with Blueberry Compote

Oven-Roasted Tomato Gazpacho
with Herb-Scented Georgia White Shrimp

ॐ **serves 6 to 8**

Oven-Roasted Tomatoes

3 pounds ripe Roma tomatoes, halved
Extra virgin olive oil
Kosher or sea salt

Oven-Roasted Tomato Gazpacho

3/4 cup Vidalia onion, finely diced
1/2 cup roasted green pepper, skinned, seeded,
 and finely diced
2 cups English cucumber, finely diced
1 clove garlic, grated
1/4 cup extra virgin olive oil
2 scallions, thinly sliced
1/4 cup rice wine vinegar
2 cups cranberry juice
1 teaspoon ground coriander
1/4 teaspoon cayenne pepper
Salt
Fresh ground pepper
Hot sauce
1/2 cup cilantro (optional)
Sour cream, for garnish

Herb-Scented Shrimp

1 1/2 quarts boiling water
2 cups white wine (Sauvignon Blanc
 or Chardonnay)
4 tablespoons kosher salt
1 tablespoons freshly ground pepper
1 teaspoon cayenne pepper
Juice of 1 lemon
1 teaspoon Old Bay Seasoning
1 tablespoon brown sugar

1 pound Georgia White Shrimp, peeled
 and deveined, with tails left on

Shrimp Seasoning

4 tablespoons fresh dill, finely chopped
1/2 teaspoon brown sugar
2 tablespoons rice wine vinegar
1 tablespoon white wine
1 cinnamon stick
1 teaspoon crushed red pepper flakes
1/2 teaspoon kosher or sea salt
2 juniper berries, finely ground

To make the oven-roasted tomatoes, toss the tomato halves liberally with the olive oil and sprinkle moderately with kosher or sea salt. Place the tomatoes on a baking sheet or ovenproof dish spaced evenly (about 1/4-inch) apart with the wide ends facing up. Roast the tomatoes in the oven at 250 degrees F for 2 hours, rotating the pan and turning the tomatoes over at least once. Roasting overnight with only the pilot light or the warm setting on an electric oven is best. To make the oven-roasted tomato gazpacho, puree the roasted tomatoes. They can also be used whole in soups, pizzas, sauces, or as a side dish.

To make the soup, soak the onion in ice water for 15 minutes to remove any bitterness. Mix the 4 cups roasted tomato puree, onion, roasted green pepper, cucumber, garlic, olive oil, scallions, rice wine vinegar, cranberry juice, coriander, and cayenne together in a large mixing bowl. Season with salt, pepper, and hot sauce to taste. Chill in the refrigerator for 1 to 2 hours before serving with the Herb-Scented Shrimp.

Season 6 cups water in a large saucepot with the white wine, salt, ground pepper, cayenne, lemon juice, Old Bay, and brown sugar. To cook the shrimp, bring the seasoned water to a rapid boil over high heat. Fill a separate large bowl with ice water and set aside.

Add the shrimp to the boiling water and remove from the heat. Stir the shrimp every 30 seconds until they are

just evenly pink. Allow the shrimp to sit in the water another 45 seconds, then transfer immediately to the bowl of ice water to stop the cooking. Chill the shrimp in the ice water for 5 to 8 minutes, then transfer them to a paper towel and blot dry.

Make the seasoning mix for the shrimp by mixing together the fresh dill, brown sugar, rice wine vinegar, white wine, cinnamon stick, red pepper flakes, salt, and juniper berries in a small mixing bowl. Place the dry shrimp in a medium-sized mixing bowl and toss with the seasoning mix. Chill the shrimp for at least 1 hour, or overnight, before serving over the oven-roasted tomato gazpacho.

The Hunt

Hunting has long been a way of life in the South. Whether working with dogs that love to search the fields and fence rows looking for quail or tracking wild boar from a tower stand, hunters provide plenty of game for fall menus. Georgia's excellent population of bobwhite quail came as the accidental result of low intensity agricultural and forestry practices in the late 1800s to mid-1900's. Wild boar were introduced first by Spanish expeditions in the 1520s and later by the British in the 1800s. Boars are wild hogs either of Russian boar stock or wild hogs that were bred with domestic pigs. For the last 50 years, the Georgia General Assembly has opened the legislative session with an annual wild hog supper. Today, nearly every county in Georgia is inhabited by wild boars making them a popular quarry of the South Georgia hunter. Typically the hunt begins early in the morning as plantation buggies carry hunters to the field. By noon they return, ready for a hearty meal.

Mixed Greens Salad with Roasted Pears, Toasted Pecans, and White Truffle Vinaigrette

serves 8 to 10

Roasted Pears
4 Anjou pears, peeled, cored, and cut in
 1/4-inch cubes
Canola oil, as needed to coat
1/4 teaspoon kosher salt
1/2 tablespoon rice wine vinegar
1 tablespoon brown sugar
2 tablespoons Port

Dressing
3/4 cup canola or olive oil
1/4 cup rice wine vinegar, seasoned
 with red pepper flakes
White truffle oil, a few drops
Kosher salt
Fresh ground peppercorn blend

Fresh salad greens of your choice
Toasted pecans (available at your grocery)

Toss the cubed pears in a mixing bowl with enough canola oil to coat, and sprinkle them with 1/4 teaspoon salt. Spread the pears evenly onto a baking sheet and bake at 350 degrees F, turning occasionally, until their edges are brown and they are tender but not mushy. Transfer the pears to a mixing bowl and toss with the rice wine vinegar, brown sugar, and Port. Refrigerate for 1 hour or overnight.

To make the dressing, combine the oil and vinegar in a medium mixing bowl. Add a few drops of the white truffle oil, and season with salt and pepper to taste. Whisk vigorously until the dressing turns opaque.

Toss the dressing with the greens, garnish with the roasted pears and toasted pecans, and serve.

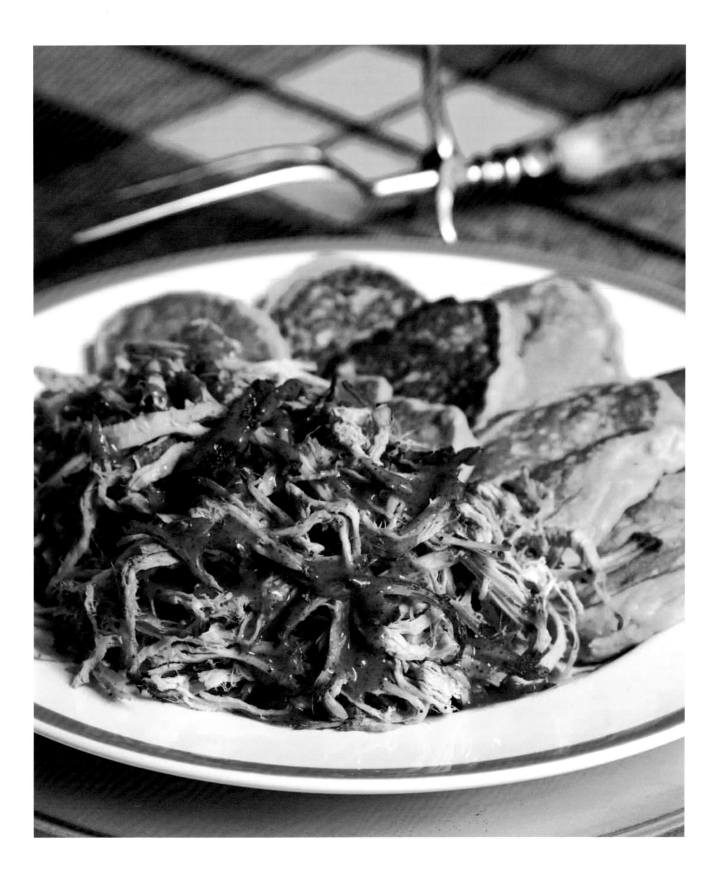

Hickory-Smoked Boar over Sweet Potato Hoe Cakes

serves 8 to 10

Hickory-Smoked Boar
1 (5-pound) boar shoulder (Broken Arrow
 Ranch recommended), small Boston butt,
 or pork shoulder, rinsed and patted dry
1 cup cider vinegar
Soaked Hickory or Cherry wood chips

Dry Rub
1 cup brown sugar
3/4 cup kosher salt
1/2 cup chili powder
1/4 cup paprika
1/2 cup coriander
1/4 cup fresh ground pepper
1/4 cup garlic powder

Sweet Potato Hoe Cakes
Yields 2 dozen (2-inch) cakes
2 medium sweet potatoes (about 12 ounces each)
Olive oil, as needed for roasting
1 1/4 cups sour cream
1 cup White Lily Self-Rising Flour
2 eggs
1 tablespoon water
Salt and pepper
Nutmeg, fresh grated
2 ears corn, silk removed, kernels removed
Clarified butter or canola oil, for frying

Rinse and dry the meat, then place it in a large mixing bowl with the cider vinegar, submerging the meat in the liquid. In a separate bowl, mix the brown sugar, salt, chili powder, paprika, coriander, pepper, and garlic powder together to make the rub. Season the meat liberally by rubbing the seasoning into the surface of the meat.

In a stove-top smoker or wok, place the meat onto a rack 2 inches above the wet Hickory or Cherry wood chips. Using foil or the wok lid, cover the meat tightly to keep as much smoke in as possible. Place the wok or smoker onto the stove over medium heat and cook until the chips become fragrant and begin to smoke. Turn the heat to low and smoke for 10 to 20 minutes, or until the smoke subsides. Turn off the heat and allow it to sit for 5 minutes.

Preheat the oven to 250 degrees F. Transfer the meat to a deep casserole dish or Dutch oven fitted with a roasting rack—the sides of the dish must be at least 1 inch higher than the meat. Press parchment paper down over the meat and pour half water and half cider vinegar to a 1/4-inch depth in the bottom of the dish. Cover the top of the dish with 4 layers of plastic wrap. Wrap more plastic wrap around the dish to ensure that the layers are secure. Cover the plastic with a layer of heavy-duty foil, crimping it tightly around any exposed plastic. Cook the meat in the oven for 6 hours. Once the meat is tender, cool it slightly in the baking dish and shred the meat. Toss it with your favorite Vidalia onion barbecue sauce to serve.

To make the hoe cakes, toss the potatoes in enough olive oil to coat and roast them in a 375-degree-F oven with the skin on until tender. Press the roasted potatoes through a food mill or potato ricer. Mix in the sour cream and flour until well incorporated. Beat the egg and water together and add them to the potatoes, along with the salt, pepper, and nutmeg to taste. Add the corn. The mixture should be the consistency of thick pudding—add more flour to thicken the mixture if needed.

Scoop the potato cakes into a skillet with canola oil over high heat—each cake should be about 2 inches wide. Cook until both sides are browned. Serve the potato cakes warm immediately or refrigerate for later use. Warm the cakes in the oven for 5 to 10 minutes before serving.

Pan-Fried Quail with Stone Ground Buttermilk Grits and Red-Eye Gravy

⁀⁀ serves 6 to 8

Quail

12 to 16 (2 per serving) semi-boneless
 dressed quail, Manchester Farms recommended
4 eggs, beaten
1 cup whole cultured buttermilk
Canola oil, for frying
Flour, for dredging
Salt
Pepper

Brine

3/4 cup white sugar
3/4 cup brown sugar
1 cup salt
8 tablespoons jerk seasoning
6 cups water

Red-Eye Gravy

6 strips cooked bacon, cut into
 1/2-inch squares, fat reserved
1 onion, diced
4 ounces ham, diced
3 tablespoons flour
1/4 cup Bourbon
1 1/2 cups chicken stock
1/2 cup ketchup or tomato puree
8 ounces smoked sausage, sliced,
 sautéed, and drained
1 bay leaf
1 teaspoon garlic powder
1 teaspoon kosher salt
1/4 teaspoon cayenne pepper

1/2 teaspoon fresh ground pepper
1/2 teaspoon Old Bay Seasoning
1 teaspoon hot sauce (Red Hot brand)

Buttermilk Grits

1 package grits
Water, as needed
Heavy cream, as needed
Whole cultured buttermilk, as needed
Salt
Pepper
Garlic powder (optional)

Use quail that is skinless with the ribcage intact for easier frying and even cooking. Make the brine by combining the sugars, salt, and jerk seasoning in 6 cups water. Soak the quail in the brine for 12 to 15 minutes, then drain and pat dry. In a separate bowl, combine the egg and cultured buttermilk. Soak the quail in the buttermilk mixture for 20 minutes or in the refrigerator overnight. While the quail is soaking, place the flour in a shallow bowl and season as desired with salt and pepper. Toss the quail with the seasoned flour, shaking off any excess. Pan-fry or deep-fry the quail in the canola oil at 375 degrees F until the quail is golden brown and has reached an internal temperature of 165 degrees F. Set aside.

To make the gravy, sauté the onion and ham with the bacon fat in a 2-quart, heavy-bottomed saucepot until the ham is lightly browned. Add in the flour and stir until the flour is lightly browned and there are no remaining lumps. Deglaze the pan with the Bourbon (use caution

when pouring the Bourbon into the saucepot— the alcohol may flame up in the pan, but the flame will burn out shortly). Gradually add in the chicken stock, stirring vigorously to prevent lumps from forming. Add in the ketchup, sausage, bay leaf, garlic powder, salt, cayenne pepper, ground pepper, Old Bay, and hot sauce. Allow the gravy to simmer for 1 hour, stirring frequently, or until the desired thickness is achieved.

Cook the grits in a small saucepot according to the directions on the package, but using only 1/3 of the water instructed. Season the grits with salt and pepper and add 1/3 of the package's recommended liquid volume of heavy cream (for example, if the package instructs to use 1 cup water, add in 1/3 cup heavy cream). Once the grits begin to thicken, add 1/3 of the liquid volume of cultured whole buttermilk. Stir the grits frequently while cooking until the desired consistency is achieved. Season with garlic powder and add additional cream or buttermilk, if needed.

Serve the quail over the buttermilk grits with red-eye gravy, and garnish with crispy bacon.

Selection of Cheese with Savannah Bee Company Honeycomb, Drunken Apples, and Crackers

serves 8

Drunken Apples
4 Gala apples, peeled, cored and cut into
 1/4-inch cubes
2 tablespoons butter
1 teaspoon brown sugar
2 tablespoons Cognac

Savannah Bee Company honeycomb
Water crackers
Cheeses of your choice

Preheat the oven to 350 degrees F.

To prepare the apples, toss the cubed fruit in a mixing bowl with enough canola oil to coat and sprinkle them with 1/4 teaspoon salt. Spread evenly onto a baking sheet and bake, turning occasionally, until the edges are brown and they become tender but not mushy. Transfer the apples to a mixing bowl and toss with the butter, brown sugar, and Cognac. Continue mixing until the butter is fully melted. Serve warm with Savannah Bee Company honeycomb, crackers, and a selection of your favorite cheeses.

Lemon Cornmeal Cake with Blueberry Compote

serves 8 to 10

Blueberry Compote

1 pint fresh blueberries
1/4 cup sugar
1 pinch kosher salt
2 tablespoons sloe gin, blackberry
 brandy, or ruby Port
6 mint leaves, thinly sliced
1/2 teaspoon cider vinegar or fresh
 squeezed lemon juice

Rosemary Syrup

3 large sprigs fresh rosemary
3/4 cup water
2 cups sugar
1 small pinch kosher salt

Lemon Cornmeal Cake

1 cup yellow cornmeal
1/2 cup cake flour or all-purpose flour,
 plus more for pan
1 3/4 teaspoons baking powder
1 cup sugar
1/2 cup (1 stick) unsalted butter,
 plus more for pan
1/2 teaspoon vanilla extract
1/4 teaspoon kosher salt
Zest of 3 lemons
2 eggs
3/4 cup milk

To make the compote, combine the blueberries, sugar, salt, alcohol, mint, and vinegar or lemon juice in a mixing bowl. Allow the ingredients to macerate for at least 1 hour before serving.

While the berries are macerating, make the rosemary syrup. Bring the water, sugar, and salt to a simmer. Add the rosemary and turn off the heat. Steep the rosemary in the water for 30 minutes.

To make the cornmeal cake, preheat a convection oven to 325 degrees F (or a non-convection oven to 350 degrees F). Butter and flour one 10-inch cake pan and line the bottom with parchment paper. Flour the sides of the pan.

Sift together the cornmeal, flour, and baking powder in a mixing bowl and set aside.

In the work bowl of a mixer fitted with the paddle attachment, cream together the sugar and butter. Add in the vanilla, salt, and lemon zest and beat until fluffy. Add in the eggs and beat until fluffy. Alternately add the cornmeal mixture and the milk to the batter, mixing at medium speed, until the mixture is just incorporated and no lumps are visible. Be careful not to overmix. Using a rubber spatula, scrape the batter into the prepared cake pan and smooth evenly.

Bake in the preheated oven for 25 minutes, or until a skewer or cake tester comes out clean. Turn once after 8 minutes. Remove the cake from the oven and allow to cool slightly. Invert onto a large plate and then invert again (the bottom of the cake in the pan will be the bottom on the final plate). Pierce the top of the cake with a skewer or knife tip, then pour slightly warmed rosemary syrup over the cake. Serve with warm blueberry compote and your favorite vanilla ice cream.

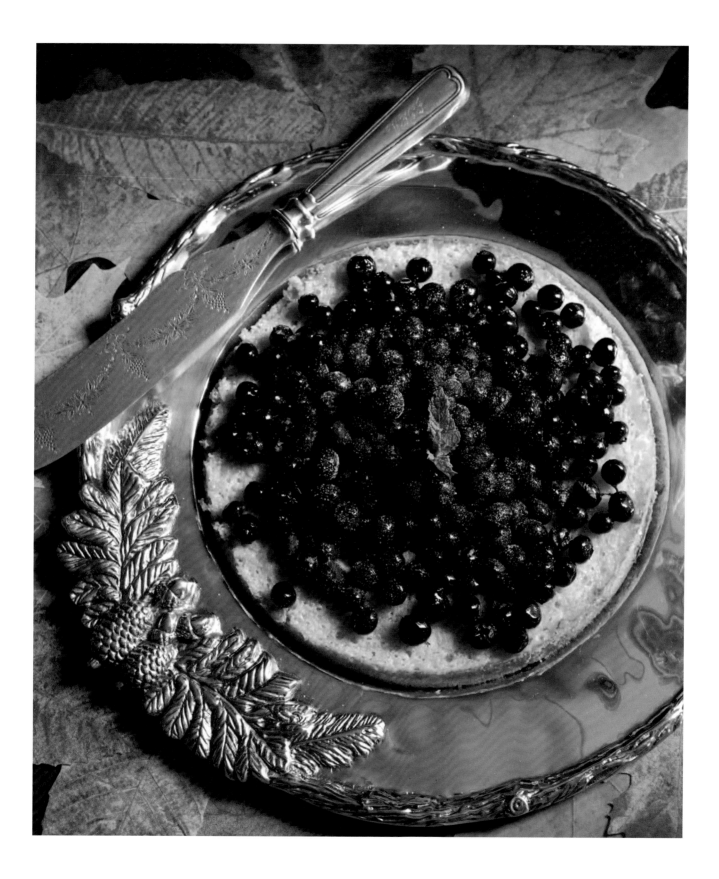

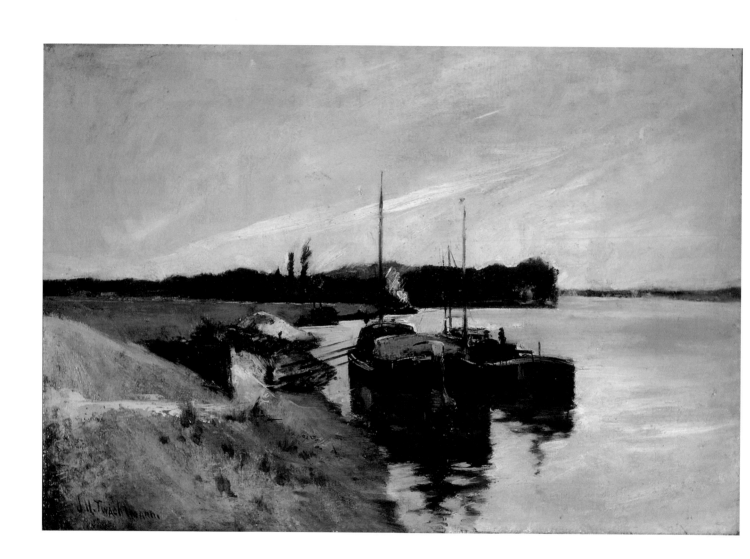

John Henry Twachtman
(American, 1853-1902)
Mouth of the Seine, c. 1884-85
Oil on canvas, 15 x 22 1/8 in.
(38.1 x 56.2 cm)
Bequest of Elizabeth Millar Bullard 1942.6

John Henry Twachtman's *Mouth of the Seine* is
part of a group of paintings bequeathed to the
Telfair in 1942 by former Trustee Elizabeth Millar
Bullard, who assembled her noteworthy collec-
tion with the advice and assistance of Gari
Melchers. Twachtman was a native of Cincinnati
but spent much of his early career traveling and
studying in Europe. *Mouth of the Seine* depicts a
scene in the French seaside resort of Honfleur,
but the artist is far more concerned with color,
composition, and structure than with the specific
rendering of a particular location. The subdued,
tonalist color palette creates a hazy atmosphere,
and the landscape lacks any easily identifiable
landmarks. The two boats, coupled with the ves-
sels' reflections in the calm waters of the river, vi-
sually anchor the composition. The sky and the
river are nearly identical in color; they evoke the
feeling of a calm day on the banks of a tranquil
river, possibly for harvesting oysters for a roast.

Down by the Riverside

MENU BY
Susan Mason

Tomato Sandwiches

Jumbo Lump Crab with Pink Sauce

Baby Green Salad with Candied Walnuts
and 45 South Dressing

Grilled Quail

Shrimp and Tasso Gravy over
Creamy White Grits

Heywood's Jalapeño Cornbread

Almond Roca

Tomato Sandwiches

❧❧ yields 40

8 ripe tomatoes
80 slices white sandwich bread
3 cups mayonnaise
2 tablespoons Lawry's Seasoned Salt

Peel the tomatoes by first cutting an "X" across the bottoms, then dipping them in boiling water until the skins pop, about 1 minute. Slice each tomato to yield 5 slices. Place the slices on a tray between paper towels and refrigerate them overnight to drain. Cut the bread into rounds with a 3-inch biscuit cutter.

Mix together the mayonnaise and seasoned salt in a small bowl until evenly combined.

Spread the bread rounds with the mayonnaise mixture. Place a tomato slice on one piece of bread and close with another. Repeat the process until all the bread rounds and tomato slices are used. Arrange on a tray to serve.

Oyster Roasts

Thoughts turn to Oyster Roasts with the first fall cold snap, when oysters are at their plump best. Working at low tide from small flat bottom boats, such as Twachtman depicted in *Mouth of the Seine*, oystermen pry the mollusks loose from beds in shallow coastal creeks, then the oysters are placed on a grate over a hot coal fire pit. There, covered with wet burlap, they steam until the shells begin to pop open, and they are shoveled onto plank tables set up under the trees by the marsh or riverside. Guests stand around the tables, opening the oysters with a glove and knife. Cocktail sauce and lemon butter round out the roast, which is typically followed by a hearty meal of Low Country seafood, game, and other favorites.

Jumbo Lump Crab with Pink Sauce

∽ serves 8

2 cups mayonnaise

1/2 cup ketchup

1/4 cup brandy

8 to 10 ounces mesclun greens

1 pound jumbo lump crab meat, drained

100 toast points

Make the pink sauce by combining the mayonnaise, ketchup, and brandy in a small bowl and mixing well. Arrange a bed of greens on a platter. Mound the crab on the greens and pour the pink sauce over the top. Serve with toast points made from your favorite bread.

Baby Greens Salad with Candied Walnuts and 45 South Dresing

∽ serves 6 to 8

Candied Walnuts

1 cup walnut halves

1/2 cup confectioners' sugar

Vegetable oil, for frying

1/4 teaspoon salt

1/8 teaspoon cayenne pepper

45 South Dressing

1 cup balsamic vinegar

7 tablespoons Dijon mustard

7 tablespoons light brown sugar

1 cup olive oil

1 cup vegetable oil

5 to 6 ounces mesclun greens

1/2 cup dried cranberries

2 Bosc pears, cut in wedges

8 ounces fresh goat cheese, cut into
 1-ounce rounds

In a medium saucepan, cover the walnut halves with cold water. Bring to a boil. Reduce the heat and simmer for 5 minutes, or until the walnuts are slightly softened. Drain the walnuts and transfer them to paper towels to dry.

In a bowl, stir together the walnuts and confectioners' sugar.

In a heavy pot, heat 3 inches of vegetable oil to 350 degrees F. Add the walnuts in batches and fry for 1 to 2 minutes, or until they are crisp. As they are fried, use a slotted spoon to transfer the candied walnuts to a baking sheet. Season the walnuts with salt and cayenne, and let cool.

To make the dressing, blend the vinegar, mustard, and brown sugar in a food processor. Slowly add the oils while the processor is running. The dressing should be thick.

Toss together the greens, cranberries, and walnuts. Drizzle the salad with dressing and top with the pears and goat cheese rounds. Store the remaining dressing in the refrigerator for up to 2 weeks.

Grilled Quail

1/4 cup hoisin sauce (available in
 Asian section of grocery)

3 tablespoons Chinese chili sauce with garlic

3 tablespoons dark sesame oil

3 tablespoons honey

2 tablespoons sesame seeds

1 teaspoon ground ginger

8 quail, dressed, or 16 quail breasts

1 (14-ounce) can chicken broth

2 teaspoons cornstarch

In a large bowl, combine the hoisin sauce, chili sauce, sesame oil, honey, sesame seeds, and ginger. Add the quail, turning to coat. Cover the bowl and refrigerate for 30 minutes.

Meanwhile, prepare a medium-hot fire in a gas or charcoal grill. Remove the quail from the marinade and reserve the marinade. Grill the quail for 30 minutes or until done, turning once.

Pour the reserved marinade into a medium saucepan. Pour 1/4 cup of the chicken broth into a small bowl and pour the remainder into the saucepan. Bring the contents of the saucepan to a boil over medium heat. Meanwhile, whisk the cornstarch into the reserved broth until smooth. Whisk the cornstarch mixture into the simmering marinade and cook for 1 minute, or until thickened. Serve the sauce with the quail.

Note: This dish can be served as an appetizer on skewers with duck breast and passed with the sauce in the middle of the tray for dipping.

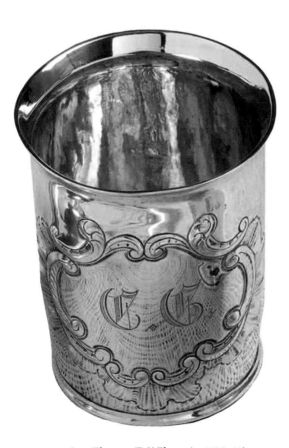

Cup, **Thomas T. Wilmot** (c. 1837–41)

Shrimp and Tasso Gravy over Creamy White Grits

serves 6 to 8

Grits

2 cups coarse stone-ground quick white grits
6 cups water
Salt
1 cup chicken broth
1 cup heavy cream
1/4 cup (1/2 stick) unsalted butter
Fresh ground pepper

2 pounds shrimp, peeled and deveined

Tasso Gravy

1/4 cup (1/2 stick) unsalted butter
1/2 cup sliced tasso, diced (smoked ham
 may be substituted)
1/2 cup all-purpose flour
4 cups chicken broth
1 tablespoon Old Bay Seasoning
1 teaspoon Lawry's Seasoned Salt

Wash the grits by running them under cold water in a colander. Bring the water and 1/2 teaspoon salt to a boil in a heavy-bottomed saucepan. Slowly pour in the grits, stirring constantly. When the grits begin to boil, add in the chicken broth. Reduce the heat to low and stir constantly so the grits do not settle at the bottom. The grits will plump up and become a thick mass after about 5 minutes. Continue to cook the grits for 20 to 25 minutes, stirring frequently, until they absorb all the liquid and become soft. Stir in the heavy cream and cook for another 10 minutes, or until the grits are the consistency of oatmeal. Add the butter and cook until melted. Season with salt and pepper and transfer to a plate. Set aside.

To blanch the shrimp, bring a large pot of salted water to a boil. Drop the shrimp in and reduce the heat to a simmer. Cook the shrimp in simmering water for 3 to 5 minutes, or until pink. Drain well.

To make the gravy, melt the butter in a medium saucepan over low heat. Add the tasso and sauté for 1 minute, or until the meat is slightly browned. Make a roux by adding the flour and stirring until well combined. Add the chicken broth to the roux, stirring vigorously until the broth begins to thicken. Add the Old Bay Seasoning and Lawry's Seasoned Salt. Drop the shrimp into the hot gravy and heat a few more minutes. Pour the gravy over the grits and serve.

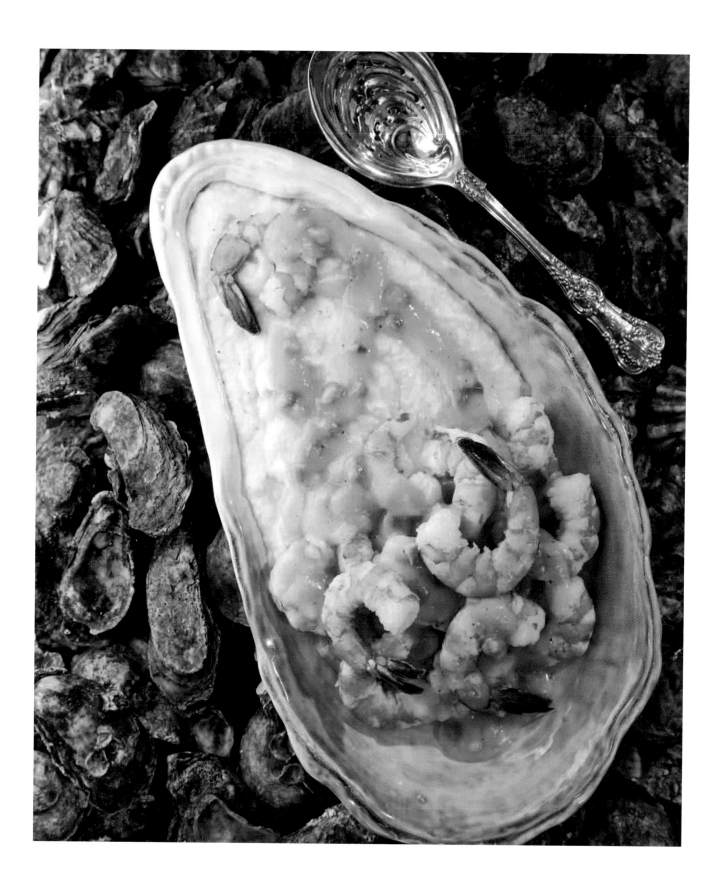

Heywood's Jalapeño Cornbread

serves 6

3 large eggs, beaten

1 cup sour cream

1 (15-ounce) can cream-style corn

1 1/2 cups chopped green onions (scallions),
 green and white parts only

1 tablespoon fresh jalapeño pepper, chopped

1/2 teaspoon baking soda

1/2 teaspoon salt

1/2 teaspoon sugar

6 ounces sharp cheddar cheese, grated

6 ounces Monterey Jack cheese, grated

1 1/2 cups yellow cornmeal

1/4 cup vegetable oil

Preheat the oven to 350 degrees F.

Mix together the eggs, sour cream, corn, green onions, jalapeño, baking soda, salt, and sugar. Stir until well blended. Stir in two-thirds of the cheddar cheese and two-thirds of the Monterey Jack cheese and mix well. Add the cornmeal and mix well.

Pour the oil into a 12-inch cast-iron skillet and heat over medium-high heat until the oil is smoking hot, swirling the oil as it heats to coat the bottom and sides of the skillet. Pour the hot oil into the batter and stir it quickly to melt the cheese. Pour the batter into the hot skillet. (You can use a 9 by 13-inch baking pan instead, if desired.)

Sprinkle the remaining cheddar and Monterey Jack cheese evenly on top. Bake for 40 minutes, or until lightly browned and crispy on top.

Allow the cornbread to sit for 15 minutes before slicing and serving directly out of the skillet.

Almond Roca

1 cup sliced almonds (with brown edges)
1 cup (2 sticks) salted butter
1 cup sugar
12 (1 1/2-ounce) Hershey's Milk Chocolate
 with Almonds bars

Cover a 17 by 12-inch cookie sheet with aluminum foil. Sprinkle half the almonds over the sheet.

Combine the butter and sugar in a heavy skillet and cook over high heat, whisking once the butter is melted. Whisk constantly for 20 to 25 minutes, or until the mixture turns a deep caramel color—do not allow the butter to burn.

Spread the butter mixture over the almonds on the prepared cookie sheet.

Melt the Hershey bars in the top of a double boiler over simmering water. Whisk until smooth. Spread the melted chocolate over the top of the caramel mixture. Sprinkle the remaining 1/2 cup almonds on top.

Let the chocolate cool and then cover the pan with foil. Refrigerate until ready to serve, then break into 1-inch pieces.

François Bonvin
(French, 1817–1887)
La cuisine, rue des Coches
(The Kitchen, Rue des Coches), 1880
Oil on canvas, 21 7/8 × 18 3/8 in.
(55.6 × 46.7 cm)
Signed and dated upper center, on mantel,
F. Bonvin 1880
Museum purchase 1911.3

A largely self-taught, nineteenth-century realist painter, Bonvin produced intimate compositions drawn from his own immediate environment that recall Dutch and Flemish works of the seventeenth century. Bonvin's scenes portray interiors he actually knew or lived in, as in this depiction of his kitchen on the Rue des Coches in St. Germain-en-Laye. Bonvin's paintings are generally hushed genre scenes, reflecting the daily activities of a humble existence. In this scene, a devotional print hung above the fireplace indicates religious piety, while the calm activity of the figures denotes faithful dedication to domestic duties. A maid stands over a steaming pot near the open window, while the artist's faithful companion, Louison Kohler, sits in a chair at the right, addressing her needlework. In the background, a contented cat licks milk from a saucer and a copper pot boils on the fire. Warm light pours in from the window, glancing across the scrupulously clean tile floor in the tidy, well-appointed kitchen. These details underscore the theme of domestic peace and tranquility, while harkening back to an established tradition of domestic genre painting. Although the season is not specified, the autumnal warmth of the palette and the substantial dress of the women suggest that it might be an early fall day, with the window thrown open to the fresh, cool air—a day perfectly suited to comfort food like hearty vegetable soup, mashed potatoes, and roasted root vegetables.

Straight from the Hearth

MENU BY
Cynthia Creighton-Jones

Hearty Vegetable Soup with Basil

Peasant Braised Veal Shanks

Roasted Root Vegetables

Cape Brandy Pudding

Hearty Vegetable Soup with Basil

❧ serves 6

5 tablespoons olive oil, divided
4 whole cloves garlic, peeled
2 large leeks, chopped, white portion only
2 stalks celery, roughly chopped
2 carrots, peeled and roughly chopped
1 white onion, peeled and roughly chopped
1/4 head cabbage, thinly sliced
1 (28-ounce) can whole tomatoes, chopped,
 juice reserved
6 cups chicken stock
Salt
Pepper
Pinch sugar
6 basil leaves, torn
1/3 cup Parmesan cheese, grated, plus
 more for garnish

Preheat the oven to 350 degrees F. Heat 1 tablespoon of olive oil in a small ovenproof saucepan over medium heat. Add the garlic cloves and sauté until they are fragrant. Cover the pan with aluminum foil and transfer it to the oven. Roast the garlic cloves for 10 minutes, or until they are soft. Remove from the oven and allow them to cool. Using the flat side of a knife, crush the garlic cloves and set them aside.

Chop the vegetables so that they are all roughly the same size to allow for even cooking. Heat the remaining olive oil in a large pot over medium heat. Sauté the leeks, celery, carrots, onion, and cabbage for 10 minutes, or until the vegetables are tender and just beginning to brown. Add the crushed roasted garlic and sauté 1 minute more. Add the tomatoes and their juices and the chicken stock. Reduce the heat and simmer, uncovered, for 45 minutes. Season the soup with salt and pepper to taste. If the soup is a too acidic, add a pinch of sugar to taste. Add the basil leaves and simmer for 1 minute more. Stir in the 1/3 cup Parmesan cheese. Serve, passing additional Parmesan around the table.

Water dipper, 1859
Unknown maker

Peasant Braised Veal Shanks

8 to 10 large (2 1/2-inch-thick) veal shanks,
 patted dry
Salt
Pepper
4 tablespoons all-purpose flour
3 tablespoons olive oil, plus more if necessary
7 tablespoons unsalted butter
1 1/2 medium onions, finely diced
2 medium carrots, peeled and finely diced
2 ribs celery, peeled and finely diced
2 cloves garlic, finely chopped
1 bay leaf
1 1/2 cups dry white wine
1 (28-ounce) can whole tomatoes,
 drained and chopped
2 to 4 cups chicken broth
1 bouquet garni (a cheesecloth bag
 containing 6 sprigs fresh Italian parsley,
 4 sprigs fresh thyme, 1 bay leaf)

Gremolata
1/2 cup Italian parsley, finely chopped
2 tablespoons lemon zest, freshly grated
1 tablespoon garlic, finely chopped

Tie the veal shanks with butcher string to keep the meat on the bone. Season the veal shanks with salt and pepper. Dredge them in the flour, shaking off the excess. In a heavy skillet, heat the olive oil over medium-high heat and brown the shanks on all sides. Transfer the shanks to a plate.

Preheat the oven to 325 degrees F.

Add the butter to the skillet and sauté the onions, carrots, celery, garlic, and bay leaf, stirring occasionally, until the onions are soft. Deglaze the pan with the white wine, scraping up any brown bits left on the bottom. Add the tomatoes, chicken broth, and bouquet garni to the pan. Bring the liquid to a boil, and then add the veal shanks back into the pan. Cover with a lid or aluminum foil and braise the shanks in a preheated oven for 2 hours, or until the veal is tender.

While the veal is braising, make the gremolata. In a bowl, stir together the parsley, lemon zest, and garlic.

Using a slotted spoon, transfer the shanks to an oven-proof serving dish. Remove the strings and keep the shanks warm. Place the skillet with the vegetables and juices over medium heat. Reduce the braising liquid as desired, skimming the fat off the surface. Remove the bay leaf and bouquet garni, adjust the seasoning as needed, and pour the sauce and vegetables over the shanks. Sprinkle the gremolata over the braised veal shanks and serve.

Roasted Root Vegetables

✺ **serves 6**

2 medium carrots, peeled

3 medium turnips, peeled

3 medium parsnips, peeled

1 celery root, peeled

2 medium red beets, peeled

2 gold beets, peeled

1 tablespoon fresh thyme, chopped

1 tablespoon fresh oregano, chopped

1 tablespoon fresh rosemary, chopped

1/4 cup olive oil

Salt

Pepper

Preheat the oven to 350 degrees F. Cut all the vegetables into 2-inch lengths. To keep the turnips, parsnips, and celery root from turning brown, keep them in lemon water while you prepare the other vegetables.

In a large bowl, mix the chopped herbs, olive oil, salt, and pepper. Add all the vegetables to the oil mixture and toss to coat evenly. Lay the vegetables out in a single layer on a greased shallow baking pan. Bake in the oven, turning the vegetables over once, for approximately 1 hour or until cooked through and tender.

The Telfair Kitchen

The kitchen doors of the Telfair mansion often stood open to the back garden, now the Sculpture Gallery of the Telfair Academy.

Inside, eight call bells, each with a different tone, rang to summon the servants to the rooms upstairs. The cook prepared meals in the large fireplaces using cranes, Dutch ovens, spiders, long-handled waffle irons, and a huge oven capable of roasting several pigs or turkeys at once.

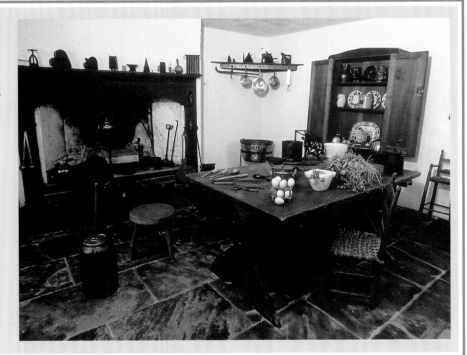

Cape Brandy Pudding

serves 6

Pudding

1 teaspoon baking soda
1/4 pound dates, pitted and finely chopped
1 cup boiling water
1/2 cup (1 stick) butter
1 cup sugar
2 eggs, beaten
2 cups cake flour
1 teaspoon baking powder
1/2 teaspoon salt
1 cup pecans or walnuts, chopped

Brandy Sauce

1 cup sugar
3/4 cup water
3 tablespoons butter
1 teaspoon vanilla extract
1/2 cup Brandy

Garnish

1 to 2 cups whipped cream

Preheat the oven to 350 degrees F. Grease a 9-inch spring-form pan and set aside.

In a bowl, combine the baking soda and half the dates. Pour the boiling water over the dates, mix well, and allow to cool. In a standing mixer fitted with the paddle attachment, cream together the butter and sugar, then beat in the eggs. Mix well.

In a separate bowl, sift together the cake flour, baking powder, and salt. Fold the flour mixture into the butter mixture and add the dry dates and the chopped nuts, mixing well. Stir in the baking soda and date mixture and mix thoroughly. Pour the batter into the prepared pan and bake for 40 minutes, or until a toothpick inserted in the center comes out clean. Remove from the oven and allow the pudding to rest.

While the pudding is baking, make the brandy sauce. Bring the sugar and water to a boil and cook until the sugar dissolves completely. Remove the sauce from the heat and stir in the butter, vanilla extract, and brandy. To serve, pour the sauce over the warm pudding and let set for 5 minutes. Carefully remove the pudding from the spring-form pan, place on a serving platter, and serve with whipped cream.

The pudding can be made ahead and reheated at a low temperature in the oven. It can also be frozen, defrosted and reheated. Do not pour the brandy sauce over the pudding before freezing.

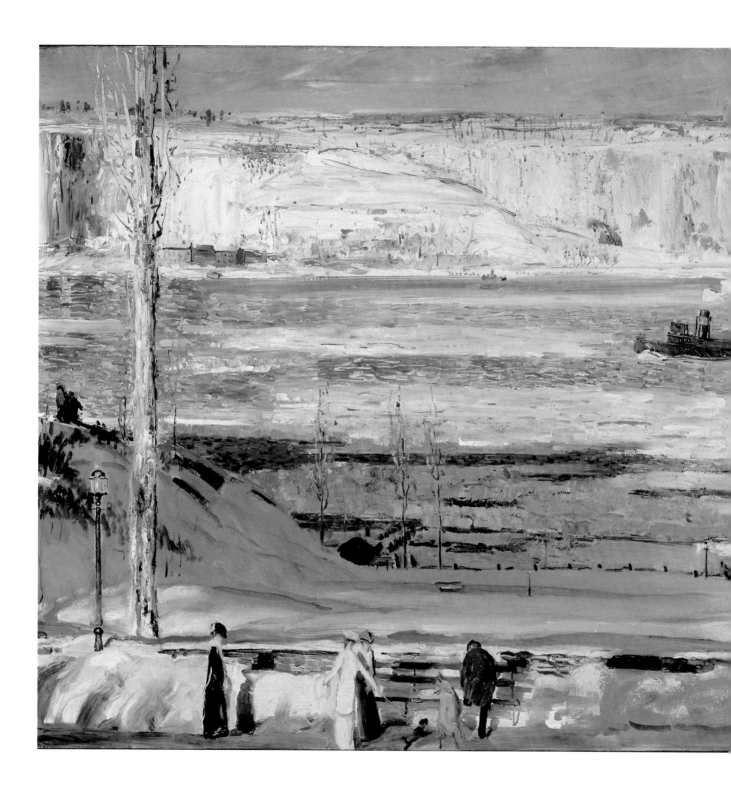

Winter

Intimate Gathering
Menu by Nick Mueller

In from the Cold
Menu by Trish McLeod

Southern Traditions
Menu by Paula Deen

Irish Inspiration
Menu by The Committee

George Bellows
(American, 1882–1925)
Snow-Capped River, 1911
Oil on canvas, 45 1/4 × 63 1/4 in. (114.9 × 160.6 cm)
Museum purchase 1911.1

George Bellows' *Snow-Capped River*, depicting a view of the Hudson River and the Palisades from Manhattan's Riverside Park, is one of the Telfair's most important and beloved paintings. Most of Bellows' urban landscapes were painted during the winter; the artist once wrote to a friend, "There has been none of my favorite snow. I must allways [sic] paint the snow at least once a year." Bellows was in the habit of taking long wintry walks in Riverside Park, where he observed and recorded the bustling life along the Hudson River, translating those experiences into paintings back in his studio. While many of Bellows' paintings of New York are teeming with activity, *Snow-Capped River* is quiet and lyrical. Diminutive figures in the foreground make their way along a path, banked with snow. In the middle distance, the river, formed of heavily textured strokes denoting the swiftness of the current, meets the gleaming cliffs of the New Jersey Palisades in the background.

Bellows' palette in *Snow-Capped River* is enlivened by a predominant emerald green, used in tandem with blues and whites to convey the crispness of a winter day and the brilliance of sunlight glancing off newly fallen snow. Yet his color scheme is not entirely cool: the river, interspersed with bluish-white ice floes, also contains strokes of lavender, pink, and yellow. Elsewhere touches of red are strategically placed to lend a radiant counterpoint to the chill greens and blues. Full of vitality, the painting suggests not the frozen torpor of winter but rather its invigorating clarity.

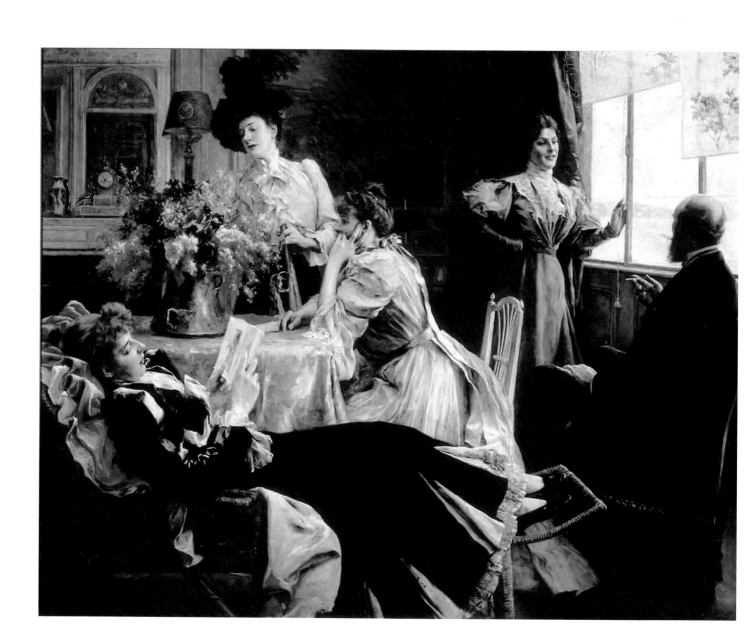

Julius LeBlanc Stewart
(American, 1855–1919)
Intimate, 1897
Oil on panel, 31 3/4 × 39 7/16 in. (80.6 × 100.2 cm)
Signed and dated lower right, J L Stewart 97
Bequest of the artist 1920.2

The title of this richly detailed painting, *Intimate*, brilliantly sums up its content. Gathered in close proximity in a well-appointed Parisian parlor, a group of friends converse, read, and relax in one another's company. Their relationship is clearly one of ease, informality, and deep familiarity; in nineteenth-century parlance, these figures are on intimate terms. A reflection of Parisian high society around the turn of the twentieth century, the painting may portray Stewart's friends and acquaintances, who often appeared in his works. The reclining figure, in particular, bears a strong resemblance in dress and disposition to the figure of the famous French actress Sarah Bernhardt, whom Stewart had painted some years earlier in the company of Swedish opera singer Christine Nillsen.

The son of a wealthy expatriate art collector, Stewart was born in Philadelphia, but moved to Paris with his family when he was ten years old and remained there most of his life. For a time during the late nineteenth century, he ranked as one of the most popular expatriate American painters in Paris. In 1921, following the artist's death, *Intimate* was specifically selected by his friends Gari Melchers, Walter MacEwen, and Jean Beraud for the Telfair's permanent collection. The painting's warm tones and the relaxed, convivial attitude of the figures evoke an intimate gathering in the company of good friends, perhaps awaiting a meal of winter offerings including oysters, beets with orange, and eggs with truffles.

Intimate Gathering

MENU BY
Nick Mueller

Pork Crostinis

Arugula Salad with Sweet Grape Tomatoes, Walnuts, Gorgonzola, and White Truffle Vinaigrette

Pan-Fried Eggs with FriedCapers and White Anchovies

Oysters Nicholas with Caramelized Onions, Bacon, and Asiago Cheese

Beet Salad with Oranges and Shallots

South African Milk Tart with Berry Salad

Pork Crostinis

꘎ **serves 6 to 8**

Marinade

1/4 cup orange juice

1 teaspoon garlic, minced

1/2 teaspoon orange zest

1 teaspoon brown sugar

Salt

Pepper

1 tablespoon rice wine vinegar

1 tablespoon onion, finely diced

1 small hot pepper, seeded and diced

1 (1 1/2 pound) pork tenderloin

1 French baguette, sliced

Truffle oil, as needed

2 large onions, caramelized

1 jar fire-roasted marinated red peppers

10 ounces goat cheese

In a large bowl, combine the orange juice, garlic, orange zest, brown sugar, salt and pepper to taste, rice wine vinegar, onion, and hot pepper and blend well. Place the pork tenderloin in the marinade, making sure it is covered on all sides, and marinate it in the mixture for at least 30 minutes.

Remove the tenderloin from the marinade and heat the grill to medium heat. Grill the tenderloin for 7 to 12 minutes on each side, or until the meat is medium rare. Remove it from the heat and allow it to rest for 5 minutes before slicing.

Rub the baguette slices with the truffle oil as desired. Toast the slices. Serve the tenderloin on the toasted baguette with the caramelized onions, fire-roasted marinated red peppers, and goat cheese.

Arugula Salad with Sweet Grape Tomatoes, Walnuts, Gorgonzola, and White Truffle Vinaigrette

serves 6 to 8

Vinaigrette
3/4 cup canola or olive oil
1/4 cup red pepper-flavored rice wine vinegar,
 or 1/4 cup rice wine vinegar with 1 teaspoon
 red pepper flakes
White truffle oil
Kosher salt
Fresh ground peppercorn blend

Salad
12 ounces arugula
1 pint sweet grape tomatoes, whole
1 cup walnut pieces
4 ounces Gorgonzola cheese

Combine the oil, vinegar, and red pepper flakes, if needed. Add a few drops of the white truffle oil, and season with kosher salt and pepper to taste. Whisk vigorously until the dressing becomes opaque.

Toss with the arugula greens, sweet grape tomatoes, walnut pieces, and Gorgonzola cheese and serve immediately.

Pan-Fried Eggs with Fried Capers and White Anchovies

serves 6 to 8

1 cup balsamic vinegar
6 to 8 eggs
1 (12-ounce) package bacon or duck fat,
 for cooking
Sea salt
Fresh cracked pepper
1 (3 1/2-ounce) jar capers
Black truffle oil
1 (2-ounce) can anchovy fillets
Parmigiano-Reggiano cheese, shaved,
 for garnish
1 bunch fresh basil, thinly sliced

To make a balsamic reduction, bring the balsamic vinegar to a boil in a small saucepan. Reduce heat and simmer until the vinegar has reduced to 1/4 cup liquid. Let the reduction cool to room temperature.

Fry the eggs in the bacon or duck fat. In another pan, fry the capers in some of the bacon fat and season with fresh cracked pepper and sea salt.

Drizzle the eggs with truffle oil and balsamic reduction, and serve with anchovy fillets (one filet per egg). White Italian anchovy fillets are wonderful, but if they are not aviable, then any anchovy fillets may be substituted.

Garnish with 1/2 teaspoon fried capers per egg, a little shaved Parigiano-Reggiano cheese, and fresh basil.

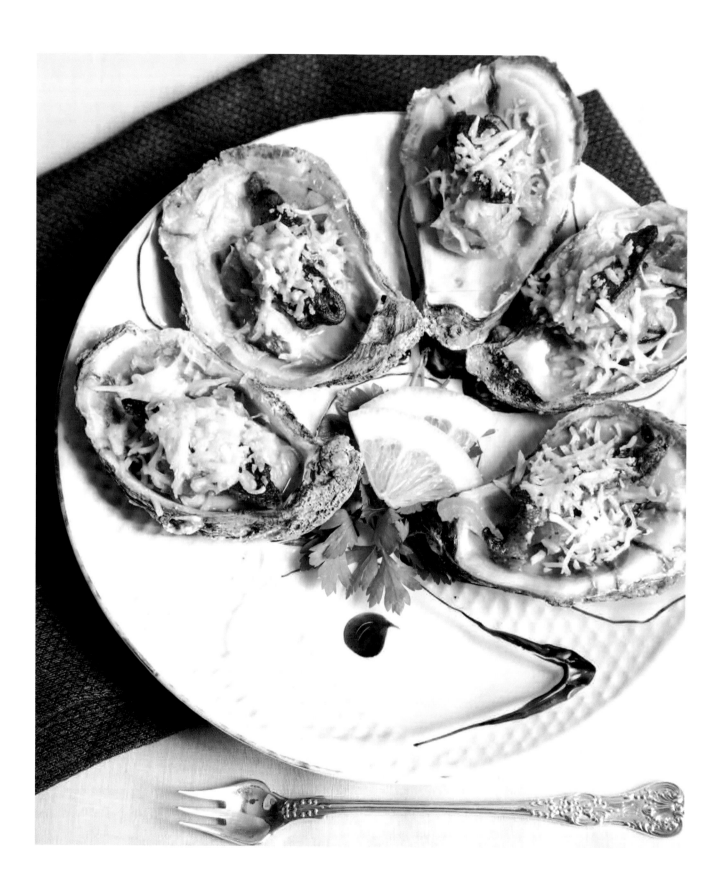

Oysters Nicholas with Caramelized Onions, Bacon, and Asiago Cheese

~ **yields 2 dozen**

24 oysters, shucked, top shell removed
 and discarded
8 strips bacon, cut into 1/2 x 3/4-inch strips
4 jumbo Vidalia onions, peeled and thinly sliced
2 tablespoons (1/4 stick) whole butter,
 plus more for onions
2 sprigs fresh rosemary
Freshly shredded Asiago cheese, for topping

Place the shucked oysters on a baking sheet with a lip. Keep them refrigerated until ready to prepare.

Cook the bacon in a heavy-bottomed skillet until crispy. Remove the bacon from the pan and place on paper towels to drain.

Caramelize the onions in a generous amount of butter with the sprigs of rosemary in a heavy-bottomed pan over medium-high heat. Once the onions are wilted, reduce the heat to medium. Once the onions are completely caramelized—they will be a dark brown—turn off the heat and season with salt and pepper to taste. Stir in 1 tablespoon of butter until it is fully incorporated. Remove the rosemary sprigs and needles and set the onions aside.

Preheat the oven to its broiler setting.

Top the oysters with the onion mixture and garnish them with the bacon and Asiago cheese. Brown the oysters under the broiler until the cheese is melted and lightly browned and serve immediately.

Beet Salad with Oranges and Shallots

serves 6 to 8

Salad

4 raw beets, peeled and thinly sliced on
 a Japanese mandolin
1 orange, segmented, juice reserved
2 shallots, finely sliced and reserved
 in ice water

Dressing

1/4 cup orange juice
2 tablespoons rice wine vinegar
1/2 cup canola oil
1 tablespoon grated ginger
Salt
Pepper
1 tablespoon honey or brown sugar,
 or to taste

Combine the beets and orange segments in a serving bowl. Drain the shallots from the ice water and add them to the salad. Toss to combine.

In a small bowl, combine the orange juice, rice wine vinegar, canola oil, ginger, salt and pepper to taste, and honey or sugar if desired. Whisk to combine and toss the dressing with the beet salad to serve.

South African Milk Tart with Berry Salad

Milk Tart
4 cups whole milk
1 cup sugar, divided
2 tablespoons (1/4 stick) butter
2 cinnamon sticks
2 tablespoons flour
3 tablespoons cornstarch
1/2 teaspoon salt
4 eggs, separated
1/2 teaspoon pure vanilla extract
1/2 teaspoon natural almond extract
1/2 teaspoon ground cinnamon

Shell
2 deep-dish pie shells
1/4 cup honey
1/4 cup milk
1/4 teaspoon almond extract

Berry Salad
1 pint fresh berries
Grand Marnier orange liquor, to taste

Boil the milk, 1/3 cup sugar, butter, and cinnamon sticks in a saucepot over medium-high heat, stirring constantly so the milk doesn't burn. In a separate bowl, combine the flour, cornstarch, salt, and 1/3 cup sugar. Mix the egg yolks into the flour mixture until well combined. Temper the hot milk into the egg and flour mixture by adding in 1/4 cup of milk at a time, stirring after each addition to prevent the eggs from scrambling, until the mixture is warmed through. Once tempered, return the mixture to the saucepot.

Cook for 3 to 5 minutes, or until the mixture has thickened to the consistency of a milkshake. Add the vanilla extract, almond extract, and cinnamon, and allow the mixture to cool slightly. Remove and discard the cinnamon stick.

In a mixing bowl, whip the egg whites with the remaining sugar until stiff peaks form. Fold the egg whites into the cooled custard.

Prebake the pie shells according to the package directions until lightly golden. In a mixing bowl, combine the honey, milk, and almond extract. Remove the shells from the oven and brush the pastry with the milk mixture.

Divide the custard evenly among the shells and bake in the oven for 12 minutes at 350 degrees F, or until the custard has set. Remove the tarts from the oven and chill in the refrigerator until ready to serve. Toss the fresh berries with the Grand Marnier and serve alongside the tart.

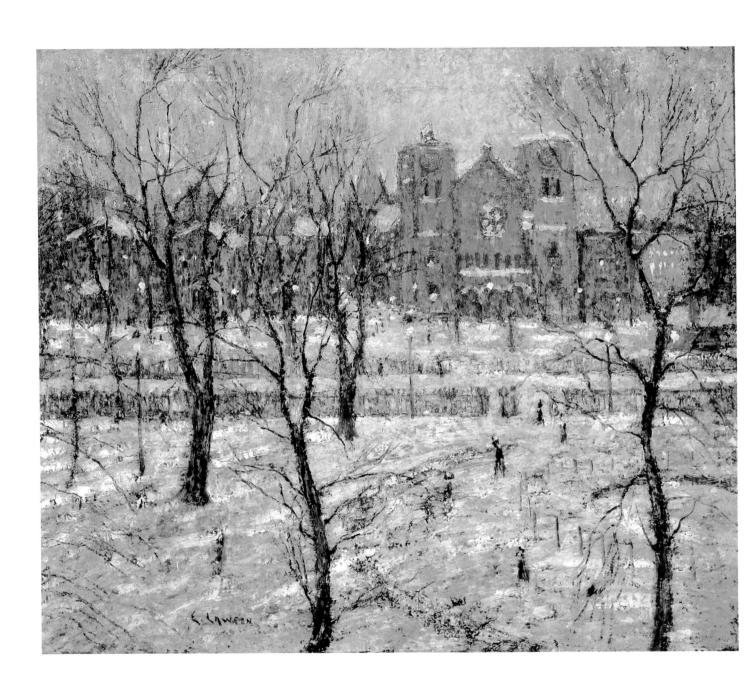

Ernest Lawson
(American, b. Canada, 1873–1939)
Stuyvesant Square in Winter, c. 1907
Oil on canvas, 25 1/8 × 30 1/8 in.
(63.8 × 76.5 cm)
Signed lower left, E. Lawson; inscription on
verso of canvas, upper left, 18 Stuyvesant
Square Snow
Museum purchase 1907.5

The artist of this poetic winter scene, Ernest Law-
son, was a student of impressionists John Henry
Twachtman and William Merritt Chase, but was
also connected to Robert Henri and his circle of
progressive realists. Lawson produced several urban
New York scenes, many of them set during the
wintertime. In this work, Lawson offers a bird's eye
view of Stuyvesant Square, located off Second Av-
enue between Fifteenth and Seventeenth Streets,
once founded as a private park but later frequented
by less privileged. This showed his populist bent.
The wintry gray of the palette is relieved by the
warm and inviting glow emanating from windows
in the church and townhouses, which twinkle
through the bare branches. Throughout the canvas,
flicks of vibrant color in a myriad of hues —the
"crushed jewels" of Lawson's palette—enliven the
composition and provide a warm counterpoint to
winter's chill. A handful of intrepid city dwellers
make their way through a park on a blustery win-
ter's day, perhaps hurrying home to a warm fire
and a hot meal in the gathering twilight.

In from the Cold

MENU BY
Trish McLeod

Coconut Pumpkin Soup

Beef Tenderloin Roast
with Blender Bérnaise Sauce

Savannah Winter Salad

Yorkshire Pudding Popovers

Coffee Toffee Trifle

Coconut Pumpkin Soup

serves 8

Fast and Easy Chicken Stock
4 cans chicken stock
1 cup onion, chopped
1 cup carrot, chopped
2 cups celery, chopped
2 cups water
4 sprigs parsley
1 bay leaf, crumbled
1 teaspoon dried thyme leaf, crumbled
5 peppercorns
Shredded chicken (optional)

Curry Powder
(Yields about 1 tablespoon)
2 teaspoons cumin powder
1 teaspoons coriander powder
1/8 teaspoon turmeric
1/8 teaspoon cardamom powder
Cayenne, chili flakes, or paprika to taste

Soup
1 large onion, minced
1 large clove garlic, minced
2 teaspoons fresh ginger, minced or grated
4 cups additional chicken stock
1 tablespoon homemade or store-bought
 curry powder (see recipe)
Cayenne pepper or paprika, to taste
4 cups cooked pumpkin, mashed, or
 2 (16-ounce) cans solid packed pumpkin
2 cans coconut milk, or 1 can coconut milk
 and 1 can chicken stock
Salt and Pepper

Garnish
Chives, toasted coconut, and mini croutons

To make the chicken stock, bring the canned stock, onion, carrot, celery, water, parsley, bay leaf, thyme, and peppercorns to a boil and simmer, partially covered, for 1 hour. Strain the liquid and allow it to cool.

To make the homemade curry, combine the cumin, coriander, turmeric, cardamom, and cayenne in a small bowl. Mix until well blended and set aside.

To make the coconut pumpkin soup, combine the onion, garlic, and ginger in enough chicken stock to cover the bottom of a large saucepan, and cook for 2 to 3 minutes, or until the onions and garlic begin to soften. Add the curry powder and cayenne. Stir in the pumpkin to coat it with the curry mixture. Add the coconut milk, or combination of coconut milk and chicken stock. Season with salt and pepper to taste.

Bring the mixture to a low boil and simmer for 5 to 10 minutes, or until the flavors marry. Add chicken stock as needed to achieve a desired thickness. Serve the soup hot, garnished with chives and toasted coconut, or mini croutons, if desired.

Note: The flavors of the dish improve if the soup is made a day ahead or earlier in the day.

Beef Tenderloin Roast with Bérnaise Sauce

serves 8 to 10

Beef Seasoning Spice Blend

1 cup parsley, chopped

1/4 cup garlic, chopped

1/4 cup shallots, chopped

1 tablespoon coarse black peppercorns

1 tablespoon granulated garlic

1 tablespoon onion powder

1 tablespoon paprika

2 teaspoons ground cayenne

1 to 2 tablespoons kosher salt

Tenderloin

6 to 8 pounds beef tenderloin,
 trimmed, not tied

4 tablespoons canola oil

1/4 to 1/2 cup beef seasoning spice blend

Blender Bérnaise Sauce

2 tablespoons shallots, chopped

1 tablespoon dried tarragon

1/4 cup white wine

1 tablespoon lemon juice

5 large egg yolks

1/2 pound (2 sticks) butter, melted,
 and hot

Cayenne pepper

Combine the parsley, garlic, shallots, peppercorns, granulated garlic, onion powder, paprika, cayenne, and salt to make the spice blend. Coat the tenderloin with oil and rub in the spice blend mixture on all sides.

Heat a grill and preheat the oven to 375 degrees F.

On the grill, sear the meat on all sides and edges until it is well browned. Place the tenderloin on a baking tray and cook in the oven for 20 to 30 minutes, or until the internal temperature reaches between 118 and 122 degrees F. Remove the tenderloin from the oven and allow it to rest for at least 15 minutes before slicing. Serve with Bérnaise sauce.

The spice rub can be stored in a sealed container in the refrigerator for up to 2 days.

To make the Bérnaise sauce, cook the shallots, tarragon, white wine, and lemon juice in a saucepan for 10 minutes, or until most of the liquid is evaporated. Place 1 tablespoon of this mixture in a blender with the egg yolks and blend. With the blender running, add the very hot melted butter in a slow stream. Season with cayenne to taste.

Note: To make a Hollandaise sauce instead, omit the tarragon mixture. Add 1 tablespoon of lemon juice with the egg yolks and then add the very hot melted butter.

Savannah Winter Salad

⁓ serves 8 to 10

Basil Pesto

1 pound fresh basil leaves
1/2 tablespoon garlic
3 tablespoons grated Parmesan cheese
1 tablespoon lemon juice
1/4 to 1/2 cup canola oil, or as needed
Salt and Pepper

Balsamic Vinaigrette

1/2 cup balsamic vinegar
1 tablespoon Dijon mustard
1/2 tablespoon garlic, chopped
1/2 tablespoons Basil Pesto
1 cup olive oil
Salt and Pepper

Salad

10 ounces locally harvested Bethesda
 winter greens (arugula, red oak, and
 baby romaine), washed and dried
2 ounces white frisee, washed and dried
3 ounces dried black figs, halved and
 soaked in warm water
1/2 pound thick smoked bacon, cubed and
 cooked until crispy
4 ounces Stilton cheese, crumbled
2 Granny Smith apples, peeled and
 cut into thin strips
2 tablespoons chopped curly
 parsley (optional)
Salt and Pepper
Pomegranate seeds, for garnish
Kumquats, thinly sliced, for garnish

To make the pesto, combine the basil, garlic, Parmesan, lemon juice, and oil in a blender or food processor. Blend until the pesto becomes a creamy paste, adjusting the amount of oil if necessary. Season with salt and pepper to taste and set aside. Any leftover pesto can be stored in a sealed container in the refrigerator for up to 3 weeks.

To make the vinaigrette, whisk the vinegar, Dijon mustard, garlic, pesto, and olive oil in a mixing bowl to combine. Season with salt and pepper as desired and set aside.

Toss the greens with the figs and bacon. Garnish the top with the crumbled Stilton, apples, and chopped parsley. Season to taste with salt and pepper. Garnish with the pomegranate seeds or kumquat slices and serve with balsamic vinaigrette.

Yorkshire Pudding Popovers

serves 10

6 eggs, lightly beaten

2 cups milk

6 tablespoons (3/4 stick) butter, melted

2 cups all-purpose flour, sifted

1 teaspoon salt

Combine the eggs, milk, and butter in a mixing bowl. Gradually add in the flour and salt and mix to combine—the batter will be lumpy. Do not beat out the lumps. This will ensure that the popovers rise properly.

Preheat the oven to 350 degrees F. Butter 10 ramekins or 20 muffin cups. Pour the batter into the ramekins, about 3/4 of the way full. Bake for 50 minutes to 1 hour. Remove from the oven and serve warm.

Coffee Toffee Trifle

serves 8 to 10

1 small angel food cake, brown parts
 removed and broken into 1-inch pieces

1/2 cup coffee liqueur

1 (3-ounce) package French vanilla
 instant pudding

2 cups half-and-half

2 cups whipping cream

2 tablespoons instant coffee granules,
 or as desired

2 tablespoons sugar

1/2 teaspoon vanilla extract

4 Skor bars (12 ounces), broken
 into coarse bits

Mix the angel food cake with the coffee liqueur and set aside

In a separate bowl, mix the pudding with the half-and-half. Add the pudding to the cake mixture, tossing gently.

Whip the cream with the instant coffee granules in a mixing bowl. Add the sugar and vanilla to the cream once soft peaks begin to form and whip until fully incorporated.

Line a trifle bowl with the cake and pudding mixture, then cover with a layer of the whipped coffee cream and the candy bar bits. Continue to layer the pudding, cream, and candy, ending with the candy on top.

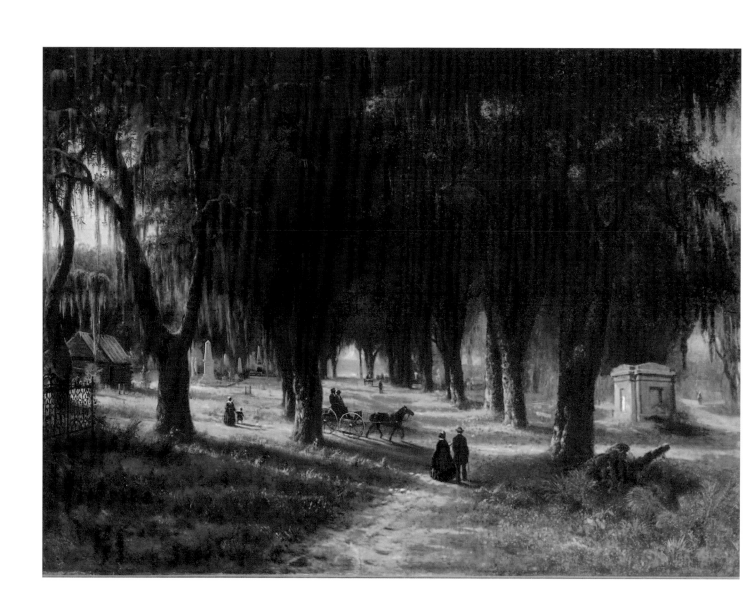

Henry Cleenewerck
(Belgian, 1818-1901)
Bonaventure Cemetery, c. 1860
Oil on canvas, 27 7/8 x 38 7/8 in.
(73.3 x 98.7 cm)
Gift of Mr. and Mrs. Gordon Washburn in
memory of Mrs. James Cary Evans
(Cecilia DeWolfe Erskine) 1967.10

Henry Cleenewerck was born near the border be-
tween Belgium and France, in the small Belgian vil-
lage of Watou. He studied painting in the nearby
towns of Poperinge and Ypres, and is first known
to have exhibited his work in 1843. Cleenewerck is
believed to have first traveled to the United States
in 1850, and spent time painting and exhibiting in
Savannah in 1860. *Bonaventure Cemetery* was ex-
hibited at Armory Hall in Savannah, where it was
purchased, and in 1967 donated to the Telfair. It
hangs in the family dining room of the Telfair's
Owens-Thomas House. Skillfully composed and
rendered, *Bonaventure Cemetery* depicts a shady
day at the historic and hallowed Savannah land-
mark. Visitors traverse the dirt paths of the ceme-
tery by foot and by horse-drawn carriage as
dappled sunlight shines through the Spanish moss-
draped live oaks in this quintessential image of a
tranquil Southern landscape, inspiring Southern
traditions like Black-eyed Peas with Hog Jowl and
Collard Greens.

Southern Traditions

MENU BY
Paula Deen

Southern Comfort Punch

Herb-Crusted Pork Loin

Collard Greens

Black-Eyed Peas with Hog Jowl

Corny Corn Muffins

The Best Bread Pudding

Southern Comfort Punch

 yields 1 1/2 gallons

Punch

1 large can frozen orange juice concentrate

3/4 cup lemon juice

1 can frozen banana daiquiri mix

1 1/2 liters ginger ale

1 (26-ounce) bottle Southern
 Comfort Whiskey

Lemonade Ice Ring

2 lemons, sliced

1 orange, sliced

2 limes, sliced

1 small jar maraschino cherries

4 cups lemonade

1 sprig mint, optional

In a large punch bowl, combine the orange juice concentrate, banana daiquiri mix, and lemon juice. Stir to blend. Slowly add in the ginger ale. Remove excess foam with a spoon and stir in the Southern Comfort.

To make the lemonade ice ring, place half of the lemons, oranges, and lime rings in the bottom of a round mold. Place the cherries in the center of the orange rings. Slowly add the lemonade, just to cover the fruit. Place in the freezer until the lemonade is frozen solid. Remove the mold from the freezer and add more fruit and the mint leaves. Slowly fill the mold with the remaining lemonade and place back in the freezer. Once frozen, place the ice ring in the punch bowl and serve.

Herb-Crusted Pork Loin

serves 6 to 8

1 (4-pound) boneless pork loin, with fat left on

1 tablespoon salt

2 tablespoons olive oil

4 cloves garlic, minced

1 teaspoon dried thyme or 2 teaspoons
 minced fresh thyme

1 teaspoon dried basil or 2 teaspoons
 minced fresh basil

1 teaspoon dried rosemary or 2 teaspoons
 minced fresh rosemary

Preheat the oven to 475 degrees F.

Place the pork loin on a rack in a roasting pan. Combine the salt, olive oil, garlic, thyme, basil, and rosemary in a small bowl. Using your fingers, massage the mixture into the pork loin, covering all of the meat and fat.

Roast the pork for 30 minutes, then reduce the heat to 425 degrees F and roast for an additional hour. Test for doneness using an instant-read thermometer. When the internal temperature reaches 155 degrees F, remove the roast from the oven. Allow it to sit for about 20 minutes before carving. It will continue to cook while it rests.

Collard Greens

serves 4 to 6

1/2 pound smoked meat (ham hocks,
 smoked turkey wings, or smoked neck bones)
1 tablespoon Paula Deen's Seasoned Salt
1 tablespoon Paula Deen's Hot Sauce
1 large bunch collard greens
1 tablespoon butter

In a large pot, bring 3 quarts of water to a boil and add the smoked meat, house seasoning, seasoned salt and hot sauce. Reduce the heat to medium and cook for 1 hour.

Wash the collard greens thoroughly. Remove the stems that run down the center by holding the leaf in one hand and stripping the leaf down with the other hand. The tender young leaves in the heart of the collards don't need to be stripped. Stack 6 to 8 leaves on top of one another, roll them up, and slice into 1/2 to 1-inch thick slices. Place the greens in the pot with the meat and add the butter. Cook for 45 minutes to 1 hour, stirring occasionally. When done, taste and adjust the seasoning.

Serve as a side to your favorite dish.

© 2006 by Paula Deen, *Paula Deen Celebrates!*

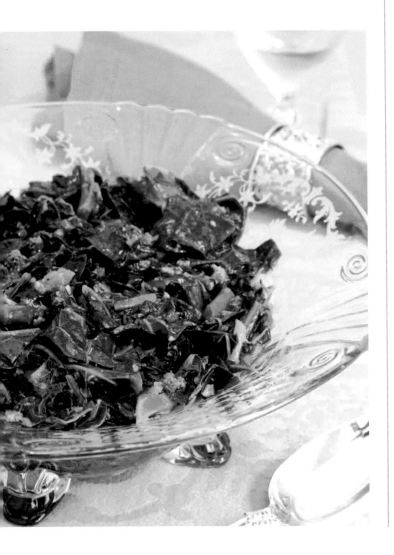

Black-Eyed Peas with Hog Jowl

serves 6 to 8

1 pound dried black-eyed peas
1/2 pound smoked meat (hog jowl, meaty
 ham hocks, smoked neckbones,
 or smoked ham)
1 teaspoon salt
1/2 teaspoon pepper
4 tablespoons (1/2 stick) butter
1/2 cup green bell pepper, finely chopped,
 for garnish
Pepper sauce, for seasoning at the table

In a large bowl, cover the peas with water and soak for 1 hour or overnight. Drain the peas and discard the soaking water.

Place the meat in a 2-quart saucepan and add 2 1/2 cups water. Bring the water to a boil, then reduce the heat to medium-low. Cover the pot and cook the meat for 30 minutes. Add the salt and pepper and peas to the meat and cook for 45 minutes, or until the peas are soft and the liquid has thickened. When done, add the butter and serve. Garnish with green pepper if desired. Serve with pepper sauce.

© 2006 by Paula Deen, *Paula Deen Celebrates!*

Corny Corn Muffins

yields 1 dozen

1 cup self-rising cornmeal mix
3/4 cup self-rising flour
1/2 cup vegetable oil
1 cup white creamed corn, fresh or frozen
2 eggs
1 cup sour cream
2 tablespoons sugar

Preheat oven to 375 degrees F and grease a 12-cup muffin tin. (If you like a crispy edge around your muffin, preheat the tin in the oven until the grease is very hot.) Combine the cornmeal mix, flour, oil, corn, eggs, sour cream, and sugar and stir until moistened. Fill the muffin cups with batter and bake for 20 minutes, or until golden brown.

© 2006 by Paula Deen, *Paula Deen Celebrates!*

The Best Bread Pudding

🍂 serves 8 to 10

Pudding

2 cups sugar

5 large eggs, beaten

2 cups milk

2 teaspoons pure vanilla extract

3 cups Italian bread, cubed, and allowed
 to stale overnight in a bowl

1 cup packed light brown sugar

1/4 cup (1/2 stick) butter, softened

1 cup pecans, chopped

Sauce

1 cup sugar

1/2 cup (1 stick) butter, melted

1 egg, beaten

2 teaspoons pure vanilla extract

1/4 cup brandy

Preheat the oven to 350 degrees F. Grease a 13 x 9 x 2-inch pan.

Mix together the granulated sugar, eggs, and milk in a bowl. Add the vanilla. Pour the mixture over the cubed bread and allow it to sit for 10 minutes.

In a separate bowl, mix and crumble together the brown sugar, butter, and pecans.

Pour the bread mixture into the prepared pan. Sprinkle the brown sugar mixture over the top and bake for 35 to 45 minutes, or until set. Remove the pan from the oven.

To make the sauce, mix together the sugar, butter, egg, and vanilla in a saucepan over medium heat. Stir until the sugar has melted. Add the brandy, stirring well. Pour the sauce over the bread pudding. Serve warm or cold.

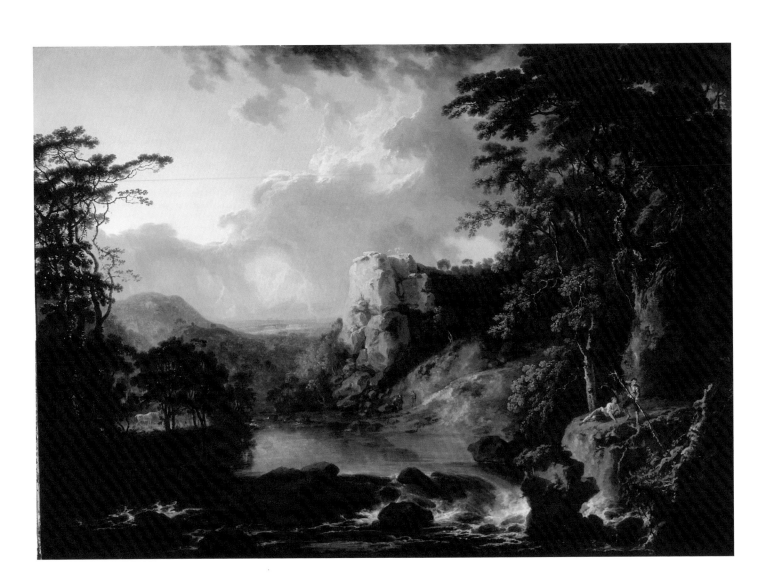

George Barret
(Irish, 1728/31–1784)
Untitled (Irish Landscape), before 1763
Oil on canvas, 54 1/4 x 76 5/8 in.
(137.8 x 194.6)
Gift of John W. Rollins Jr. 1977.135

This dramatic landscape ignites all the senses—a rushing stream crashes over a series of rocks, rain clouds roll away to reveal a golden glow, and an impressive landscape, full of fresh air, lush trees and craggy precipices, unfolds into the distance. A series of small figures explore the terrain, providing a sense of scale and underscoring the vastness of the natural surroundings. Far in the distance lies one of Ireland's most famous country estates, Powerscourt House in County Wicklow, encompassing wild stretches of the Dargle River and the highest waterfall in Ireland. Barret's particular genius lay in adapting the idealized classical landscape tradition to recognizable yet romanticized views of noble estates, or spectacular topographical sites alive with the grand power of nature. An excellent example of Romantic landscape painting, this work is an early manifestation of the concept of the sublime, embodying feelings of power and awe generated by untamed nature. This scene from County Wicklow, the lush area below Dublin known as the Garden of Ireland, encapsulates all the drama and poetry of Irish culture itself. This culture is kept alive today and inspires menus of Irish comfort food like Colcannon, made with mashed potatoes and cabbage, to be accompanied by Guinness Braised Lamb Shanks.

"Oh, wasn't it the happy days when troubles we had not, And our mothers made Colcannon in the little skillet pot."

Irish Inspriration

MENU BY
The Committee

Salmon in Crock with Garni

Guinness-Braised Lamb Shanks

Colcannon

Maple-Roasted Carrots
with Cippolini Onions

Irish Brown Bread

Bailey's Hazelnut Coffee Meringues

Salmon in Crock with Garni

serves 6

8 ounces cream cheese
4 ounces smoked salmon
1 tablespoon honey mustard
Fresh dill, for garnish

Combine the cream cheese, salmon, and honey mustard in a food processor and blend until smooth. Place the mixture in a ramekin and chill.

Garnish with dill sprigs and serve with gherkins, capers, red onions, and cocktail rye bread, your favorite crackers, or Irish Brown Bread (see recipe, p.156).

Guinness-Braised Lamb Shanks

serves 6

6 (1-pound) lamb shanks, or
 12 to 14 beef short ribs
Sea salt
Fresh ground pepper
3 tablespoons olive oil
4 cups onions, chopped
1 tablespoon garlic, minced
2 tablespoons tomato paste
3 tablespoons flour
1 cup beef stock, plus 1/2 cup if needed
1 cup chicken stock, plus 1/2 cup if needed
2 (12-ounce) bottles Guinness extra stout beer
1 tablespoon honey
1 1/2 teaspoons dried sage
1/2 teaspoon ground cloves
3 bay leaves, crumbled
Bouquet garni (5 large sprigs thyme,
 1 large sprig sage, 3 large sprigs parsley,
 secured in a cheesecloth bag)
2 cups carrots, chopped
1 cup pitted prunes, chopped
1 bunch parsley, minced, for garnish

Season the lamb shanks with salt and pepper. Heat 2 tablespoons olive oil in a heavy-bottomed Dutch oven over medium-high heat and brown the meat, in batches, on all sides. Remove the meat and drain all the fat from the pan, except for 2 tablespoons. Add the onions, garlic, and tomato paste and cook over medium heat for 10 minutes, or until soft. Stir in the flour until the onions are evenly coated, and cook for 2 minutes. Stir in the broths, scraping the bottom of the pan to loosen any browned bits, and add the beer, honey, sage, ground cloves, crumbled bay leaf, bouquet garni, and carrots. Stir in the meat and juices, and season with pepper and salt. Make sure the liquid covers the meat to ensure proper braising. Bring to a full simmer, cover, and cook over medium-low heat on the stovetop or in a 325-degree-F oven for 3 hours, or until the meat is tender and falling off the bone. Add 1 cup of chopped prunes after the first hour.

Remove the pan from the oven, remove and discard the bouquet garni, and adjust the seasoning as desired. Cook the day before and refrigerate for 24 hours before reheating and serving. Skim any fat from the surface and reheat, uncovered, over low heat for 45 minutes to allow the sauce to further reduce and thicken. The lamb can be served on or off the bone. Garnish with minced parsley.

Colcannon

 serves 6

2 tablespoons olive oil
1 leek, white part only, washed and thinly sliced
1 clove garlic, peeled and minced
1/2 medium head cabbage, cored, washed, and shredded
Sea salt
Fresh ground pepper
3 pounds unpeeled Yukon gold potatoes, scrubbed
6 tablespoons (3/4 stick) butter
3/4 cup cream or half-and-half, warm

Garnish
2 tablespoons scallions, chopped
Crumbled bacon, to taste
1 tablespoon parsley, chopped

Heat the olive oil in a large skillet and sauté the leek and garlic over medium heat. Add the cabbage and cook over low heat, covered and stirring occasionally. Add a little water if needed and cook for 30 to 45 minutes, or until tender. Season with salt and pepper and set aside.

Bring water to a boil in a large saucepot and add the potatoes to the boiling water. Reduce the heat and simmer for 20 minutes, or until the potatoes are tender. Drain the potatoes, peel, and pass them through a potato ricer. Mash the potatoes with the butter and warmed cream. Stir together the cooked cabbage and the potatoes.

Adjust the seasoning as desired and transfer to a serving bowl. To keep warm, place the bowl in the oven with a little cream on top.

Garnish with the scallions, bacon, and parsley to serve.

Maple-Roasted Carrots with Cippolini Onions

serves 6

2 pounds baby carrots
1 pound cippolini onions, ends trimmed, peeled, and halved
1 tablespoon butter
2 tablespoons olive oil
Salt
Fresh ground pepper
1/4 cup maple syrup, or to taste

Preheat the oven to 400 degrees F.

Toss the baby carrots and cippolini onions with a little butter and olive oil in a saucepan over medium heat. Transfer the vegetables to a baking sheet, and season with salt and fresh ground pepper. Roast for 20 to 25 minutes, or until the carrots and onions are nearly tender. Drizzle with the maple syrup and return the pan to the oven for 2 to 3 minutes to lightly caramelize the carrots. Transfer to a serving platter and serve.

Irish Brown Bread
☙ yields 1 (9 x 5-inch) loaf

3 1/2 cups whole-wheat flour,
 preferably stone-ground
1/4 cup all-purpose flour
2 teaspoons salt
1 1/2 packages active dry yeast
2 tablespoons molasses or black treacle
Butter, for pan

In a large bowl, stir together the flours and salt. In a separate small bowl combine the yeast and molasses in 1/2 cup lukewarm water and allow the mixture to sit for 5 to 10 minutes.

Pour the yeast mixture and 1 1/2 cups more lukewarm water into the dry ingredients and blend with a wooden spoon to make a thick, sticky dough. This will be a very stiff batter, as opposed to a dough that can be kneaded. If necessary, add up to 1/4 cup more water to achieve the desired consistency.

Turn the dough into a buttered 9 by 5 by 3-inch loaf pan. Cover the pan lightly with a tea towel and set aside to rise for 20 to 30 minutes, or until the dough nearly reaches the top of the loaf pan.

Preheat the oven to 450 degrees F. Bake the loaf in the middle of the oven for 10 minutes, then reduce the heat to 425 degrees F and bake for 35 to 40 minutes more, or until the top is richly browned and the loaf sounds hollow when tapped. Turn the loaf out onto a rack and allow it to cool completely before slicing and serving.

Bailey's Hazelnut Coffee Meringues

serves 6

Meringues
7 tablespoons sugar, divided
3 tablespoons packed light brown sugar, divided
1 teaspoon instant espresso or coffee powder
1/4 cup ground hazelnuts
2 large egg whites

Filling
1 1/4 cups chilled whipping cream, divided
1/2 tablespoon sugar, or to taste
4 tablespoons Bailey's Irish Crème Whiskey,
 or to taste
2 teaspoons instant espresso or coffee powder
Dark chocolate shavings, for garnish
Fresh mint, for garnish

Preheat the oven to 250 degrees F. Line 2 heavy baking sheets with parchment paper.

Combine 3 tablespoons sugar, 1 tablespoon brown sugar, the espresso powder, and the hazelnuts in a small bowl, stir, and set aside.

Using a handheld electric mixer, beat the egg whites in a medium bowl until medium-stiff peaks form. Add the remaining 4 tablespoons sugar and 2 tablespoons brown sugar to the egg whites, one tablespoon at a time, and beat until stiff peaks form. Fold the coffee-sugar-hazelnut mixture into the meringue.

Drop the meringue by rounded tablespoons onto the prepared baking sheets, spacing them evenly apart. Using a knife, gently spread the meringues to 2 1/2- to 3-inch rounds. Bake for 45 minutes, or until the meringues are dry and can be easily transfered to racks to cool completely. To make the filling, beat 1 cup whipping cream in a medium bowl until medium-firm peaks form. In a separate bowl stir together the sugar, Bailey's whiskey, and instant espresso powder until dissolved. Add this to the cream. Beat until firm peaks form and refrigerate until ready to serve.

To assemble, place one meringue on a plate, flat-side down and spoon a generous tablespoon of espresso cream filling on top. Top with another meringue, flat-side down, and press gently so the filling spreads to the edge. Repeat with the remaining meringues and filling. Beat the remaining 1/4 cup whipping cream in a small bowl until firm peaks form. Spoon a small dollop of cream atop each meringue. Garnish each meringue with shavings of dark chocolate and a sprig of mint and serve.

The meringues can be prepared ahead and kept in air-tight containers at room temperature for two days until ready to assemble with the filling.

St. Patrick's Day

On March 17, 1813 a small band of Presbyterian Hibernians marched through Savannah in honor of their homeland. Eleven years later, some of the thousands of Irish immigrants who had found their way to Savannah and the Low Country began the tradition of the Saint Patrick's Day parade. Today, the celebration is one of the largest in the United States. The election of the Grand Marshal, the mass at the Cathedral of St. John, the green-dyed fountains and the green-clad families marching in the streets remind today's generation of Irish descendants of their rich heritage. "Erin Go Bragh!"

Index

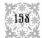

The Chefs

■ **Cynthia Creighton-Jones** has extensive international experience, with more than 20 years of cooking in exclusive hotels and clubs. After settling in Savannah in 1999, Cynthia worked as Executive Chef at both the Desoto Hilton and the Chatham Club. In 2005, Cynthia decided to take the plunge and open Cape Creations Catering, Inc. The company's mission statement truly reflects Cynthia's love of food and entertaining.

Generosity, originality, and a dash of fun are just as important as quality ingredients, professionalism, and impeccable service to Cynthia. Whether working with you to design a dream wedding, corporate event, or an intimate dinner party, Cape Creations believes in feeding your soul and your imagination as well as your stomach.

■ **Paula Deen's** remarkable career began in Savannah, making brown-bag lunches that her sons helped distribute. Now she is a best-selling author, television show host, and tastemaker to the stars—and to the everyday housewife and family, too. She has built one of the most diverse and effective media brands in entertainment today.

The recipes she shares with us in *The Artful Table* bring us back to that home-cooked goodness that started it all: family-oriented food with Paula's delicious and inimitable Southern flair.

■ **Susan Mason** has developed a legendary catering business in Savannah based on Southern manners and hospitality. Born in Alabama, she developed strong Southern roots and further enhanced her knowledge of food and culture with yearly trips to Provence, France. It comes as second nature to Susan to make people feel at home. It is often said that if Susan is catering the party, you need not worry about a thing.

Keeping an established business in Savannah and around the South relies much on word of mouth, and in Susan's case, her business has survived on "gossip promotion." According to Susan, "You're only as good as your last party," so she has never actually had to advertise her business. "My philosophy is simple: do what you do well, and serve plenty of it. The secret to a successful party is treating it like it is your own."

■ **Trish McLeod** has been catering for clients in Savannah, Hilton Head, St. Simons and the surrounding Low Country since 1987, building a loyal group of clients and growing her business largely by word of mouth.

Trish's passion for preparing and sharing food started her catering career. She is committed to providing clients with their dream menu, reflecting their specific tastes. Born and raised in Asia, she is also familiar with Mediterranean, French and Italian cuisines and, after living in Savannah for 30-plus years, has learned to serve the best of the South, too. An important part of all her dishes are the top quality, fresh local ingredients, freshly made. Beautiful presentation and impeccable service are guaranteed.

■ **Nick Mueller** is a graduate of the New England Culinary Institute in Vermont, and Armstrong State College in Savannah. Nick also received the prestigious Silver A Award for Service while at Armstrong. He is the recipient of many industry awards, including First Place and Best Savannah Themed Menu during the 2004 Magnolia Coastland Chefs Challenge. He was named 2010 Best Savannah Chef by the readership of Savannah Magazine. In 1999, he and his wife Tracy began Chef Nick Mueller & Company, a full service catering and wholesale custom baking company.

His food is a fusion of traditional Savannah cuisine and classical European preparation, with some Asian and African influences. The diverse heritages that make up Savannah's broad community are fully represented in his company's culinary style.

■ **John Nichols** grew up in the food business. From his teen years as a waiter at the Pirates' House, to his stint with Hyatt Regency Savannah as director of catering and convention services, then co-ownership of Clary's Cafe downtown and John & Linda's restaurant in City Market, John has continued a long family tradition in the food industry. Both his grandfathers and two of his uncles operated food service establishments in Savannah. After leaving City Market John began catering, and fifteen years later his commitment to colorful, clever presentations, excellent preparation and superior guest services have earned him a reputation as one of Savannah's most trusted caterers. Recently, John and his brother have re-opened the old Crystal Beer Parlor downtown, serving over 80 beers and some of the best pub fare in Savannah.

■ **The Starland Dining Group** headed by chefs Michael Pritchard and John Deaderick, are a talented and creative pair that teamed up 15 years ago as proprietors of the restaurant Good Eats on Abercorn Street. They now own and operate The Starland Cafe, a bright and cheery spot in midtown Savannah, and Cafe Zeum, the popular lunch spot in the Eckburg Atrium of the Jepson Center for the Arts.

Their food has always been global—including a big share of Southern comfort food. They pride themselves on using fresh food, featuring unique flavor combinations, and locally grown ingredients.

Acknowledgments

Drawing inspiration from the art of the museums' collection and honoring its 125th anniversary, *The Artful table: Menus and Masterpieces from the Telfair Museums* also drew on the talents and dedication of the museums' staff, members of Telfair Academy Guild and Savannah's culinary artists. While searching for a fundraising idea, the idea came quickly for a project that would combine art and entertaining—one that tantalized all the senses—and a plan took shape. The Committee was formed, and what a committee it was! Thanks to the energy and expertise of Elisabeth Biggerstaff, Sharon Bury, Jettie Hearne, Beth Logan, Carolyn Neely, Kelly Newberry and Sylvia Severance work began. Encouragement from Susan Mason and Esther Shaver gave impetus to the concept. The imagination and culinary skills of Nick Mueller, Cynthia Creighton-Jones, Susan Mason, John Nichols, Trish McLeod, John Deaderick and Micahel Pritchard from The Starland Dining Group, and Paula Deen produced inspired menus based on the collection. Thanks also to Donna Foltz and Carrie Aimar.

The Committee took on many roles, assisted by other TAG members at every turn. Carolyn Neely led research and writing for sidebars with Fran Thomas, Ann Koontz, Bette Feingold, Nancy Beauchamp and Jan Kemp. Sharon Bury and Jettie Hearne professionally mobilized a team of testers including Brenda Day, Barbara Coley, Barbara Lucas, Lorraine Alligood, Lou Barnes, Jane Barrick, Cynthia Calder, Claudette Engvall, Anne Guira, Anne Hackett, Polly Hall, Camille Hebert, Jettie Johnston, Kandy Leslie, Judy McDonough, Kathy Olen, Carolyn Orchid, Carolyn Osmun, Jane Peterson, Heather Petryk, Joanne Shapoff, Allison Smith, Kathy Smullen, Chase Umberger, Fran Vaught, Bert Vincent, plus husbands who kept the pot boiling. Sylvia Severance lent valuable publishing experience. Thanks also to Jake Severance. The speed and accuracy of Ginny Knoll and Joanne Eldred moved production along beautifully. A photo shoot organized by Elisabeth Biggerstaff, with help from many testers, assisted photographer Deborah Whitlaw Llewellyn in producing beautiful results. Thanks to Mary Canavan, Jan Curran, Molly Rice, Sweet Tea, Dale Thorpe, Bobbie Shaw, Russo's Seafoood, The Cottage Shop and Jackie Sirlin for their contributions.

Beth Logan, with members of The Committee, mounted a marketing campaign with the assistance of Brenda Day, Barbara Coley, Jody McGovern, and Carolyn Brown and Kelly Newberry whose brilliant financial acumen insured a sound footing. Kristin Boylston, Holly Akkerman and Jessica Denmark were instrumental in confirming proper procedures. The importance of Janice Shay and her assistant, Sarah Jones, to the completion of the project goes beyond words. There would be no book without them!

But it was the curatorial expertise of Holly McCullough, Courtney McNeil, Tania Sammons, Beth Moore and Jessica Mumford that gave authority to the design. Their love of the collection and willingness to lend support at every turn eased forward the process. All deserve special praise!

And no work of this magnitude happens in a vacuum. Thank you, Telfair Museums—all staff, all volunteers and all members. Excitement for *The Artful Table: Menus and Masterpieces from the Telfair Museums* provided necessary reinforcement. Gratitude goes most deeply to The Committee who will hold the Telfair's 125 year old collection ever more closely from this moment forth. Art inspires!

Linda McWhorter, *Chairman*

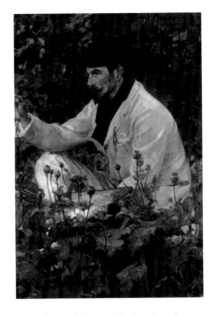

The palette of George Hitchcock and the table of Alfred Smith (cover) gave inspiration to this book.

James Jebusa Shannon
(British, born in United States, 1862–1923)
George Hitchcock, c. 1895
Oil on canvas, 51 1/8 x 35 3/16 in.
(129.9 x 89.4 cm)